Happy Retirement
Pete!

Love, Mia + Kids

IMAGES
of America

ITALIANS OF NORTHEASTERN PENNSYLVANIA

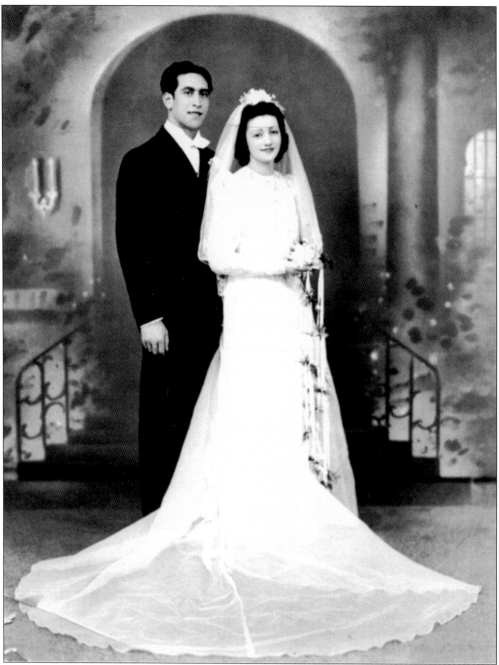

This book is lovingly dedicated to my grandparents Joseph and Anna Mascaro Longo. As true examples of what it means to be Italian-American in northeastern Pennsylvania, they taught their children that true character is reflected not through money or possessions, but through actions toward others. Because of their belief in the goodness of people, they are still fondly remembered by the Italian-American communities of Scranton and Dunmore, even though more than 30 years have passed since their deaths.

IMAGES
of America

ITALIANS OF
NORTHEASTERN
PENNSYLVANIA

Stephanie Longo

ARCADIA
PUBLISHING

Published by Arcadia Publishing
Charleston SC, Chicago IL, Portsmouth NH, San Francisco CA

Printed in the United States of America

Library of Congress Catalog Card Number: 2004106529

For all general information contact Arcadia Publishing at:
Telephone 843-853-2070
Fax 843-853-0044
E-mail sales@arcadiapublishing.com
For customer service and orders:
Toll-Free 1-888-313-2665

Visit us on the Internet at www.arcadiapublishing.com

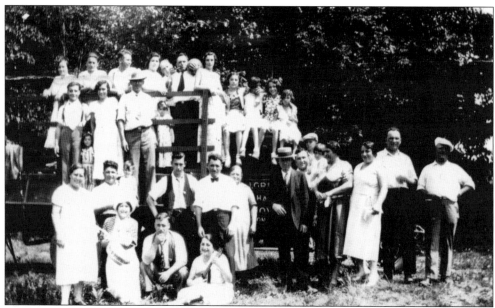

Italian parties were a must during the warm summer months of northeastern Pennsylvania. In this photograph, taken during the 1930s in Nanticoke, a group of immigrants from Nocera Umbra, Umbria, pauses to pose on a bright, sunny day. (Courtesy of the Museo Regionale dell'Emigrazione of Gualdo Tadino, Italy.)

CONTENTS

ACKNOWLEDGMENTS

This book would not have been possible without the help of many people. First and foremost, I wish to thank the entire Italian community of northeastern Pennsylvania and the many individuals who have shown support and enthusiasm for this project. I also wish to thank Dominic Candeloro of the American Italian Historical Association for suggesting that I author a book on the Italian community in which I was privileged to have been raised. To the Museo Regionale dell'Emigrazione of Gualdo Tadino, Italy, and Salvatore Boniello of the Museo di Civiltà Contadina of Guardia dei Lombardi, Italy, I am grateful for the gracious contributions of photographs and stories for this publication. I am honored to have been assisted in this project by the Order of the Sons of Italy's Enrico Caruso Lodge No. 2770, especially by president Sam Stivala and his wife, vice president Pauline "Pudgy" Stivala. To Joe Pascoe and the Italian community of Carbondale, I am elated by the typical Italian zest that was shown in the photograph-collection process of this book, and firmly believe that they are true "pioneers" of the Italian spirit of northeastern Pennsylvania. I also wish to thank the various people who contributed images and interviews to this publication, whose names are visible in the credits after each photograph. These people were kind enough to open their hearts and to allow a young woman to record their families' stories for all to share. Thanks to them, northeastern Pennsylvania's Italian community will have its own history preserved for the future.

I am grateful to Erin Loftus, my editor at Arcadia Publishing, for her trust, patience, and unending support. Through her kind words, I was able to get through some of the most difficult periods of writing, and it is thanks to her editorial expertise that this book is a truly beautiful representation of the Italian experience in northeastern Pennsylvania.

Finally, I wish to thank my mother, Ann Marie Longo, for the unconditional love and confidence that she has shown me every day since I was born. She worked right by my side through every step of this project, telling me that she believed in me and my dedication to my heritage. Because of her, I am a proud Italian-American, but my greatest source of pride is being her daughter.

By picking up this book, you have shown a desire to learn about the Italian-American heritage of northeastern Pennsylvania. To my readers, I say *grazie*.

INTRODUCTION

Chi lascia la via vecchia per la nuova sa quello che perde ma non sa quello che troverà.
"Whoever leaves the old way for the new knows what he is losing but not what he will find."

This proverb best articulates the collective experience of Italian immigrants arriving in the United States during the latter part of the 19th century and the beginning of the 20th century. These people were well aware of what they were leaving behind in Italy: their families, their friends, their birthplaces. In short, they shed the only lives they had ever known in search of something more. These brave souls did not know what was in store for them in America, yet they were all willing to do almost anything to ensure the survival of their families. Their descendants are now scattered across the United States and are, quite possibly, unaware of the sacrifices their ancestors made for them due to the process of Americanization and the more recent generations' subsequent loss of ethnic identity (Gambino 1996, 364).

When one thinks of the "Italian" regions of the United States, northeastern Pennsylvania rarely comes to mind. The area is typically associated with the boom in the anthracite coal industry, which was a direct result of the Industrial Revolution. Incidentally, this occurred in the United States at around the same time as the beginning of the first wave of immigrants that brought the Welsh, Irish, and Germans to northeastern Pennsylvania. The first recorded Italians in northeastern Pennsylvania were a group of seven living in Scranton and its surrounding areas in 1870. Statewide, roughly 784 people living in Pennsylvania in 1870 were born in Italy. In 1900, this number had risen to 484,207, with 1,312 living in Scranton (Grifo and Noto 1990, 1). This increase in Scranton's Italian population was due to the abundance of jobs that became available in northeastern Pennsylvania by virtue of the growth in the rail and coal industries in the region.

The Italians of Northeastern Pennsylvania is an attempt to acknowledge the area's rich ethnic history, while preserving it for future generations, in an easy-to-read format. It is also an attempt to recognize the Italian community of northeastern Pennsylvania as one of the region's largest and most visible ethnic groups. After all, according to the 2000 United States Census, Italian-Americans are the second-largest ethnic group in Lackawanna and Luzerne Counties, the central counties of Pennsylvania's northeastern region (Luzerne Tourism).

Americans of Italian descent encounter a void when exploring the lives of their ancestors in the *madrepatria*. So, too, towns in Italy find a lack of information regarding their emigrants' lives upon arrival in America (Boniello letter). This book ventures to fill these voids. To do so, *The Italians of Northeastern Pennsylvania* takes the form of a pictorial history, since photographs serve as the historian's most important means for demonstrating life in any given era. The final chapter of this history is a glimpse into the lives of today's Italian-Americans of northeastern Pennsylvania and is meant to encourage Italian-American youths, especially those living in the region, to be proud of their unique heritage.

Finally, this book is an open invitation to the other ethnic groups that have called northeastern Pennsylvania their home to also work toward preserving their ethnic histories in a collective format because, as another old Italian proverb states, *Se semini e curi, tutto dura* (Boniello 1999, 28), or "If you take care of what has been planted, it will last." Through efforts such as this, our ethnic identities will not be lost; they will instead be like planted seeds that continue to spring forth with new life.

One

LA VIA VECCHIA

The term *la via vecchia*, when applied to Italian migration to the United States, refers to the way of life enjoyed by the emigrants prior to leaving their homeland. Most Italians arrived in the United States as a result of cultural and social changes occurring in Italy after the *Risorgimento*, the movement to unite Italy under a single ruler, during the second half of the 19th century. Prior to this time, Italy was a series of separate states, including the Kingdom of the Two Sicilies (with its capital at Naples), the Papal States (Rome), and the Kingdom of Piedmont and Sardinia (Turin). Upon unification, the residents of the former Kingdom of the Two Sicilies found themselves in a heavy economic crisis, as they had to mortgage their lands and take out loans to meet the tax burdens imposed by the new national government (Gambino 1996, 33). The southern Italians suffered a variety of environmental disasters after unification, such as mud slides and earthquakes, as well as the phylloxera pest that destroyed more than 750,000 acres of vineyards in southern Italy (Grifo and Noto 1990, 2). Other financial difficulties ensued because grains imported from the United States were being sold at a cheaper price than those produced locally (CRESM 2001, 60).

Some northern Italians also found themselves in a position where emigration to the United States was their only option. Aside from many southern Italians, northeastern Pennsylvania also has a large number of immigrants from Italy's Umbria region. This number is so large that, as early as 1913, Fortunato Tiscar, the first Italian consulate to Scranton, wrote that Umbrians characterized the Italian population of Scranton, Old Forge, Jessup, and other Italian communities in northeastern Pennsylvania (ISUC 1989, 19). Italians emigrated from Umbria because of various forces associated with the lack of modernization in the region, including a lower quality of life and work, as well as an agricultural crisis ignited by a continued use of traditional methods instead of more modern means that would increase production (ISUC 1989, 13). Thus, the Italians who emigrated felt that they needed to work elsewhere in order to help their families survive. Word quickly spread that there were jobs to be had in the United States.

This is a view of the town of Gubbio, Umbria, which was home to many immigrants who arrived in Jessup to work in the region's coal mines. These immigrants continued the tradition of the *Corsa dei Ceri*, or the Race of the Saints, which is typically celebrated in May in Jessup as St. Ubaldo Day. (Courtesy of Caterina Tolerico Refice.)

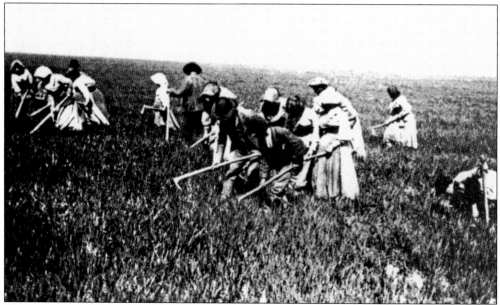

In this rare photograph *c.* 1905, a group of peasants performs the *mondarella*, or the weeding of the fields, as migrant workers from Umbria to the region of Lazio, Italy. Many Italians who decided to emigrate to the United States first labored as migrants in order to raise the funds necessary to buy their tickets, since work was scarce in their own villages or provinces. (Courtesy of the Museo Regionale dell'Emigrazione of Gualdo Tadino, Italy.)

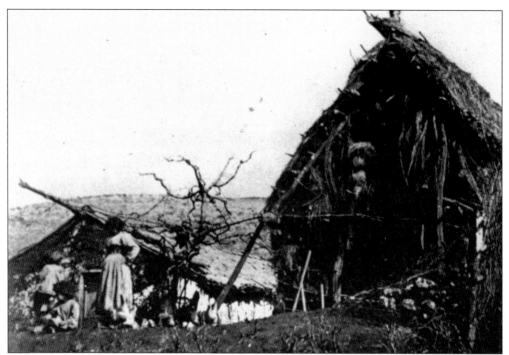

A *pagliaio* was a grass hut used as a temporary residence by the peasant class of Italians, while they worked in the fields, during the late 19th century and early 20th century. The *pagliai* were found all over Italy, especially in the more agricultural areas of the Umbrian and Campanian countrysides. (Courtesy of the Museo Regionale dell'Emigrazione of Gualdo Tadino, Italy.)

Guardia dei Lombardi, Campania, was home to many of the immigrants who settled in the Bunker Hill sections of Dunmore and Scranton. Currently, both the Museo di Civiltà Contadina of Guardia dei Lombardi and the Museo Regionale dell'Emigrazione of Gualdo Tadino, Umbria, house exhibits on the immigration of Italians from those respective towns to northeastern Pennsylvania. (Courtesy of Marina Troiano.)

When the peasants returned home from working in the fields, they tended to live in houses very similar to this one, which is located in the historic center of Guardia dei Lombardi. These houses usually had one large room that served as the kitchen, living room, dining room, and bedroom. Sometimes, the peasants who were unable to afford a stall for their animals would house them in the cellar or in a small area separate from the family's living quarters in the house. (Courtesy of Salvatore Boniello.)

Carlopoli, Calabria, is the ancestral home of many Italian-Americans living in Carbondale, which also has a significant Sicilian population. (Courtesy of Sonny Cerra.)

Many Italian-Americans living in the city of Scranton can claim ancestry from the town of Nicastro, Calabria (pictured above). During the 1960s, Nicastro was joined with the neighboring towns of S. Eufemia Lamezia and Sambiase to form the city of Lamezia Terme. (Courtesy of Assunta Orlando.)

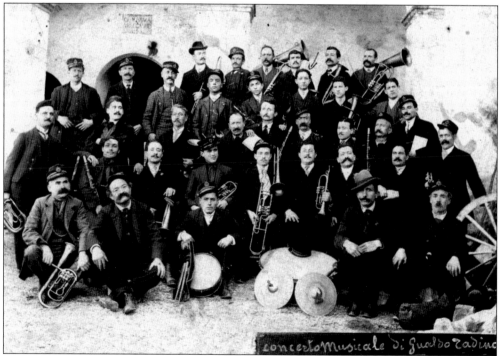

Music was a constant form of entertainment in the Italian as well as the Italian-American household. This band, named the Concerto Musicale di Gualdo Tadino (Umbria), was filled with members who eventually came to the United States. Many Italians during the late 1800s and early 1900s would spend their evenings playing musical instruments as a way of relaxing after a hard day in the fields. (Courtesy of Ron Refice.)

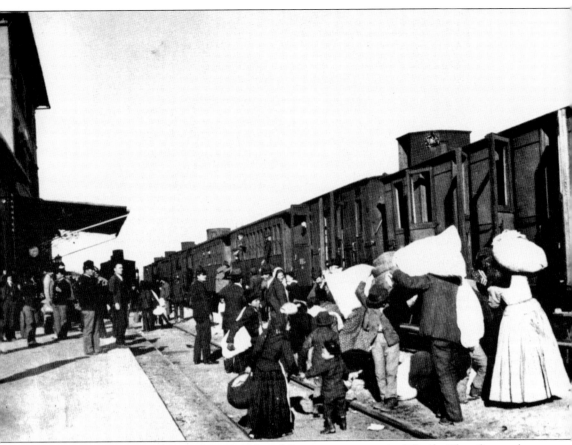

The emigrants' voyage from Italy to the United States was extremely difficult. They first took a train from their hometowns to the port of departure—either Genoa, Naples, or Palermo—and then stayed overnight in a hostel. After passing a medical exam to check for diseases, they boarded their ships the next morning. The voyage took about 10 days. Giovannina "Jennie" Luongo Moeller, who emigrated from Guardia dei Lombardi, Campania, to Dunmore in 1927 at six years old, described the voyage as "scary" because the only thing she could see was "water, water everywhere and no land in sight." (Courtesy of the Museo Regionale dell'Emigrazione of Gualdo Tadino, Italy.)

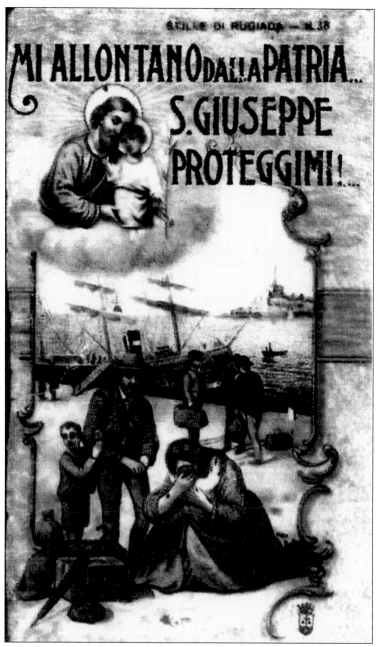

This prayer card was given to people emigrating from the former Kingdom of the Two Sicilies to the United States. The front of the card reads, "I am leaving my homeland. . . . St. Joseph, protect me!" The beginning of the prayer on the back, translated to English, states, "To you, O blessed St. Joseph, we the descendants of the great people who formed the Kingdom of the Two Sicilies, placed in a time of great tribulation, faithfully run to you and your blessed wife, the Virgin Mary, to seek your aid. Ah! For that sacred bond that links you to the immaculate Virgin Mother of God and for the fatherly love that you gave to the child Jesus, we beg you in remembrance of Jesus Christ's death on the cross, to look with your loving eye and give your power and help, to us and our brethren who have been forced to emigrate from our country."

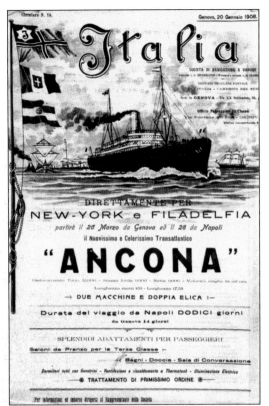

The *Ancona*, seen in this advertisement, belonged to the Italia line, which in 1908 boasted of a transatlantic voyage of 12 days as well as special amenities for its third-class passengers, such as windows in their cabins, dining rooms, baths, showers, and salons. (Courtesy of the Museo Regionale dell'Emigrazione of Gualdo Tadino, Italy.)

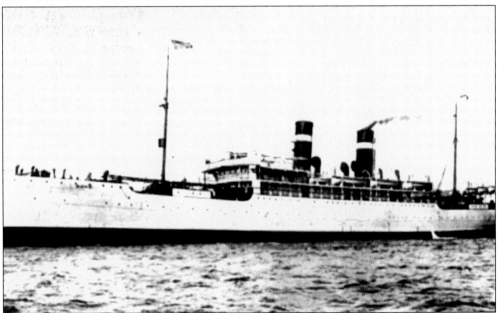

The *Roma* was built by Forges et Chantiers de la Méditerranée of La Seyne, France, in 1902 to serve as part of the Fabre line, which served the Mediterranean ports and Ellis Island. It brought many emigrants from Europe to the United States beginning in 1902 until 1928, when it was scrapped in France.

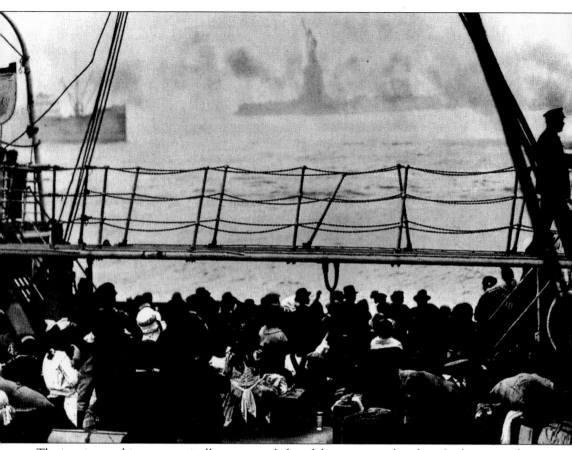

The immigrant ships were typically very crowded, and diseases were abundant. In this scene, the immigrants gather for their first glimpse at the Statue of Liberty upon arrival. After disembarking the ship, the immigrants were led into Ellis Island to be processed and to be declared fit or unfit to enter the United States. In the event that they were denied entry, they would have to go back to their country of origin or, as in the case of some immigrants, try to enter illegally or to come in through Canada. (Courtesy of the Museo Regionale dell'Emigrazione of Gualdo Tadino, Italy.)

Shown in both of these images is a letter from Mario Faramelli to his wife, Otilia. After emigrating from Gubbio, Umbria, to Scranton in 1909, Mario wrote Otilia to tell her to come to the United States as quickly as possible after taking care of the various household affairs because "Italy is hell but America is paradise." He felt that they would both be happier and more successful if they left Italy for good. (Courtesy of the Museo Regionale dell'Emigrazione of Gualdo Tadino, Italy.)

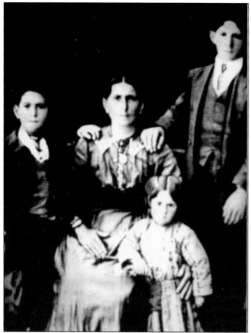

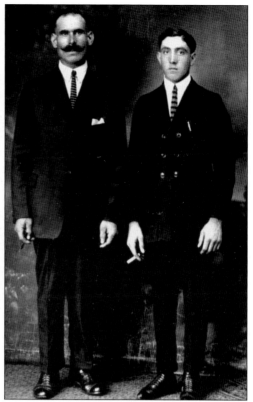

Immigration caused many families to be separated; an example of this can be seen in the Luongo family of Guardia dei Lombardi, Campania. Salvatore Luongo and his son Gaetano (above right photograph) immigrated to the Bunker Hill section of Dunmore in 1920, while Salvatore's wife, Nicoletta Castellano, and the two youngest of their other three children, Giuseppe and Giovannina (above left photograph), arrived in 1927. In 1929, Nicoletta gave birth to Antonio (bottom right photograph, at center), who did not meet his eldest brother, Angelo (above left photograph, on far right), until the 1950s because the latter had remained in Guardia dei Lombardi to marry his sweetheart and run the family farm. By the time Angelo arrived in the United States, his father had already passed away. Because of constant separation, the Luongos never had a portrait taken of their entire family. (All courtesy of Jennie Luongo Moeller.)

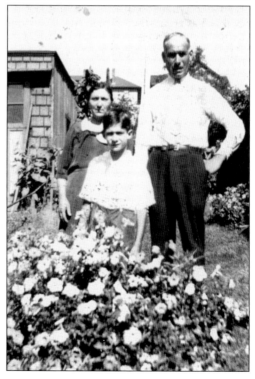

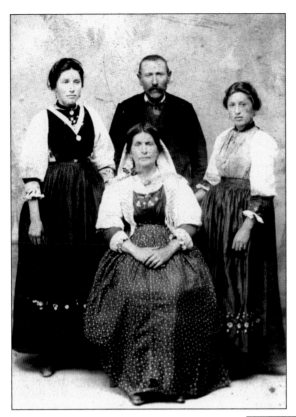

Family members in Italy often posed for photographs in their traditional costumes and printed them on postcard stock to be sent to their relatives in the United States. This image of the Zarrilli family of Calitri, Campania, was sent to the De Maio family of Dunmore in the late 1920s. The families had not seen each other since the De Maios left Calitri several years before. (Courtesy of Rosemary De Maio Fariel.)

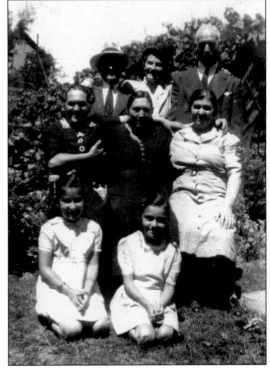

Immigration to the United States also caused entire families to be divided because of the towns in which they chose to live and work. Here, a miniature reunion of the Castellano family of Guardia dei Lombardi, Campania, occurs in the 1930s. Giuseppe Castellano (wearing the hat) settled in New York City with his wife, while his sisters Vittoria (second row, far left) and Nicoletta (second row, center) settled in Dunmore with their husbands. (Courtesy of Jennie Luongo Moeller.)

Two

LA VIA NUOVA

Upon arrival in the United States, immigrants immediately found themselves in a world much different from the one back in Italy. *La via vecchia* ceased to exist once they stepped foot off Ellis Island; from that point on, the immigrants' lives would center on *la via nuova*, the new way.

For an Italian immigrant living in northeastern Pennsylvania, *la via nuova* was a road paved with coal. The mines were one of the largest employers for newly arrived immigrants to the area, regardless of their country of origin. Unfortunately, working conditions in the mines were far from ideal; miners could spend 12 or more hours underground at the risk of losing a limb or, worse, their lives. Efrem Bartoletti, an Italian immigrant from Costacciaro, Umbria, who spent some time in Scranton, wrote a poem entitled "The Mine" (1912) that described the mines as an "almost hellish mouth, smoky and black/ and full of Death and of disaster/ fatally it opens, terrible and obscure/ in the great bosom of the earth it is the coal mine" (ISUC 1989, 52).

Labor disputes soon sprang up all over the region in protest of the cruel working conditions in the mines. One such dispute was led by an Italian immigrant to the Wyoming Valley from Perugia, Umbria: Rinaldo Capellini. On July 17, 1920, Capellini led about 8,500 employees of the Pennsylvania Coal Company on strike, demanding a stop to favoritism in the form of the contracting system, which gave the best mining sites to contractors while their employees were sent to the more dangerous areas (Scott 1973, 119). Capellini's role in this strike led to his election as president of the United Mine Workers Association, District 1, which had more than 60,000 members. Capellini was the first Italian immigrant to hold this post (*Times Leader* 2003, 30).

Besides the coal mines, Italian immigrants to northeastern Pennsylvania took jobs working for the railroads, as well as working as stonemasons, shoemakers, and barbers. The Italians quickly discovered that their new jobs in the United States were vastly different from their former lives as peasant farmers, but they refused to let their dreams of a better life be cast aside, not even by *la via nuova*.

Oscar De Lena emigrated from San Giacomo degli Schiavoni, Molise, to Pittston in 1921 to work in the coal mines of northeastern Pennsylvania. Like many immigrants, De Lena traveled between Pittston and Italy several times as a "bird of passage" before finally deciding to remain in Italy to care for his sick father. Upon his death, Oscar's father left him a considerable amount of land in San Giacomo degli Schiavoni. (Courtesy of Oscar De Lena.)

Salvatore Orlando emigrated from Acquappesa Marina, Calabria, to Hazleton to work on the railroads and in the coal mines. He traveled back and forth between Acquappesa and Hazleton for about 30 years, until he decided to return permanently to Italy in 1952 to be with his children and grandchildren, some of whom he had never seen. Unfortunately, the week before he was to leave for Italy, he passed away from complications after a heart attack. (Courtesy of Assunta Orlando.)

In this *c.* 1900 photograph, Italian coal miners from Gualdo Tadino, Umbria, take a break from their work in Old Forge to play some music before going back underground. (Courtesy of the Museo Regionale dell'Emigrazione of Gualdo Tadino, Italy.)

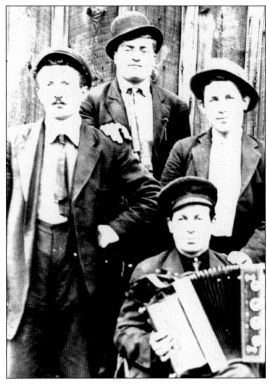

This certificate, given to Domenico Rosi of Nocera Umbra, Umbria, showed that he had passed all necessary exams in front of the Miner's Examining Board in Luzerne County to become a certified miner for Traders Coal Company. In order to receive this certificate, Rosi had to answer at least 12 questions correctly in English pertaining to the requirements of a "practical miner." (Courtesy of the Museo Regionale dell'Emigrazione of Gualdo Tadino, Italy.)

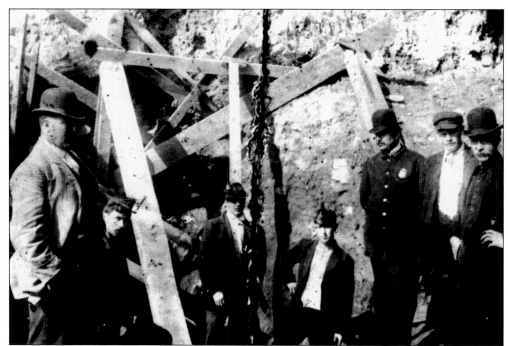

A group of Italian miners gathers in front of an opening in Old Forge in the early part of the 20th century. One of the biggest risks for a miner was "black lung," which resulted from breathing in coal dust for several hours at a time without fresh air. The inhaled coal dust became embedded in the lungs, causing them to harden, which made breathing very difficult. (Courtesy of the Museo Regionale dell'Emigrazione of Gualdo Tadino, Italy.)

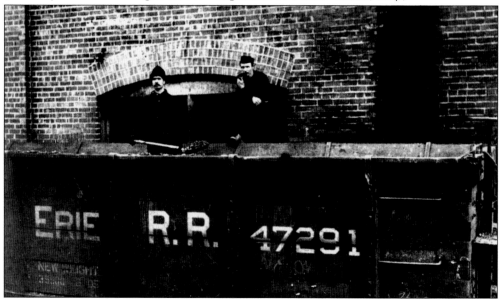

Here, in 1909, two Italian miners from Umbria who are working in Old Forge load coal onto a train so that it can be transported and sold. Northeastern Pennsylvania was rich with anthracite (hard) coal, which, during the first half of the 20th century, was used for electricity and heating. (Courtesy of the Museo Regionale dell'Emigrazione of Gualdo Tadino, Italy.)

Ettore "Edward" Coccodrilli of Gubbio, Umbria, works at the Village Hope Coal Company in Throop. Some remnants of the old coal mines can still be seen at locations across northeastern Pennsylvania, including the Anthracite Heritage Museum in Scranton, which has an authentic mine on its grounds. The decline of coal mining in northeastern Pennsylvania began in 1959, after the Knox Mine Disaster at Port Griffith, which killed 12 miners. (Courtesy of Joan Ondush.)

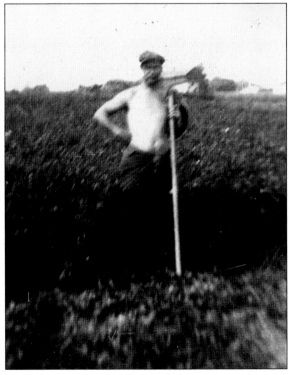

Besides working in the mines, Ettore Coccodrilli was also an accomplished dairy farmer. Here, he works in the hay fields at the Mid-Valley Farm Dairy in South Canaan Township. (Courtesy of Joan Ondush.)

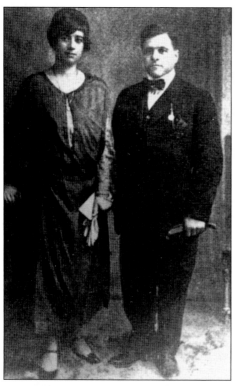

Efrem Bartoletti, seen here with his wife in 1920s Scranton, was more than just a poet who worked in the mines—he became one of the major leaders of the Industrial Workers of the World. (Courtesy of the Museo Regionale dell'Emigrazione of Gualdo Tadino, Italy.)

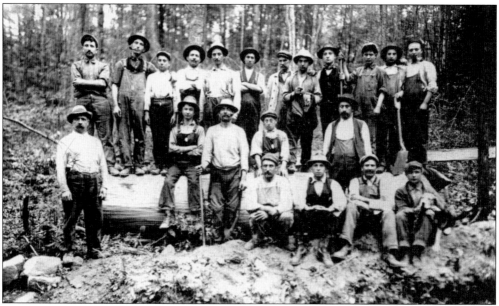

This photograph shows a group of Italian men from Williamsport who worked on the railroad in Sonestown and Kettle Creek. The rail industry was the second-largest employer of immigrants to northeastern Pennsylvania after the coal mines. In fact, the derogatory song "Where Do You Work-a John, On the Delaware Lackawan" was inspired by Italian railroad workers on the Delaware & Lackawanna Railroad in the 1920s, who spoke very broken English. (Courtesy of Joanna Daniele.)

Il Legionario (The Legionnaire) was a weekly magazine printed in Rome for Italians who lived abroad. This issue was the special Easter edition of March 11–17, 1937, and contained Easter wishes from then king of Italy Victor Emmanuel III and "Duce" Benito Mussolini. (Courtesy of Our Lady of Mt. Carmel Parish.)

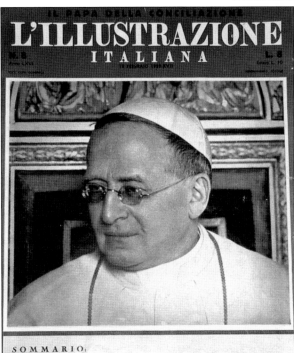

This issue of L'Illustrazione Italiana (The Italian Illustration) from the week of February 19, 1939, marked the death of Pope Pius XI. The magazine was similar to Il Legionario but contained more photographs of Italy's landscapes and less fascist propaganda. From 1916 to 1940, northeastern Pennsylvania had its own Italian-language newspaper, L'Amico (The Friend), later renamed L'Aurora (The Dawn). And in the 1890s, Peter Zannoni of Wilkes-Barre corresponded for Il Progresso Italoamericano (today America Oggi), the leading Italian-language newspaper of New York City. (Courtesy of Our Lady of Mt. Carmel Parish.)

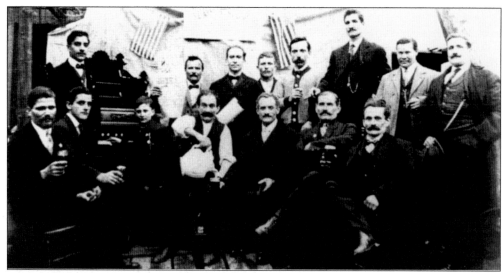

This 1908 photograph shows the Umbrian Mutual Aid Society of Jessup, which was dedicated to helping immigrants from the region of Umbria adjust to life in the United States. Other similar societies existed in Scranton with the Victor Alfieri Club, and in Williamsport with the Dante Alighieri Society. (Courtesy of the Museo Regionale dell'Emigrazione of Gualdo Tadino, Italy.)

American citizenship was coveted by many immigrants to northeastern Pennsylvania. In this photograph, Italian women living in Newberry and Williamsport pose after studying for their citizenship papers at the Lincoln School in Newberry. (Courtesy of Joanna Daniele.)

The Court Roma Number 242 of the Foresters of America was a benevolent society located in Carbondale that helped many of the new Italian immigrants upon their arrival in the country. Here, members of the Court Roma gather outside to observe a funeral procession in 1921 (see below). (Courtesy of Evelyn Pettinato.)

The medals on the left and right were worn by members of Carbondale's Court Roma. In the previous photograph, members wear the medal that is on the right, which was used in the event of a funeral. The medal in the middle was from the Cerruti Council of Carbondale, a Catholic benevolent society organized by Rev. Anthony Cerruti of Our Lady of Mt. Carmel Parish. (Courtesy of Joe Pascoe; photograph by Stephanie Longo.)

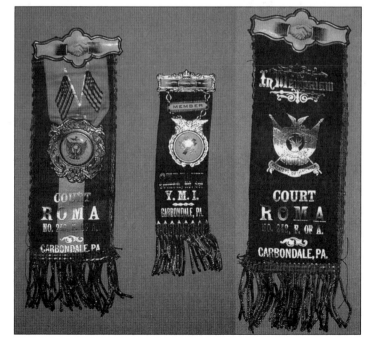

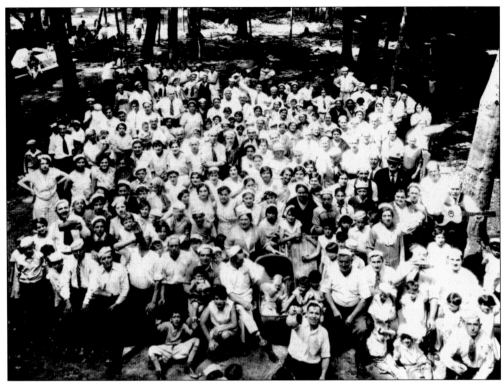

Summer was the perfect season for people who emigrated from the same town in Italy to gather and celebrate their origins. Here, in 1933, Italians from Calitri, Campania, meet at Metallo's Grove in Daleville for Calitrani Day. (Courtesy of Rosemary De Maio Fariel.)

The De Maio family of Dunmore always attended Calitrani Day. Family members in this 1921 photograph are, from left to right, as follows: (first row) Ann De Maio Gallo and Vincent De Maio; (second row) Joseph De Maio, Giovanni De Maio, Lucy De Maio Montalbano, Vincenza De Maio, Antoinette De Maio Bochicchio, and Angela De Maio Sawko. (Courtesy of Rosemary De Maio Fariel.)

The first car purchase was always a source of pride for any family during the early part of the 20th century. Here, in 1913, Francesco Cecconi of Gualdo Tadino, Umbria, sits behind the wheel of his first car in Plains. (Courtesy of the Museo Regionale dell'Emigrazione of Gualdo Tadino, Italy.)

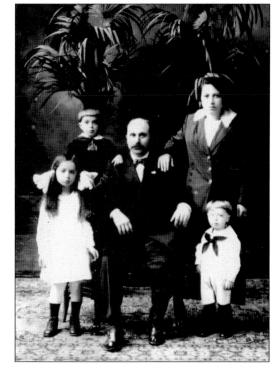

The Pinacoli family of Nocera Umbra immigrated to Pittston in 1914. In the center is Francesco Pinacoli, and to the right is his wife, Lucia Gasparri. The children are, from left to right, Maria, Fernando, and Natale. (Courtesy of the Museo Regionale dell'Emigrazione of Gualdo Tadino, Italy.)

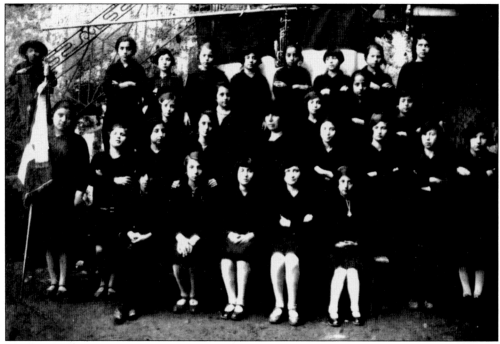

Giovanna Martelli was born in 1914 in Dunmore, but while she was young her father returned with his family to Nicastro, Calabria, his birthplace. While in Italy, Giovanna attended a school run by the fascist government. In this photograph, Giovanna holds the Italian flag and, like the other children, is dressed in fascist attire. (Courtesy of John Rettura.)

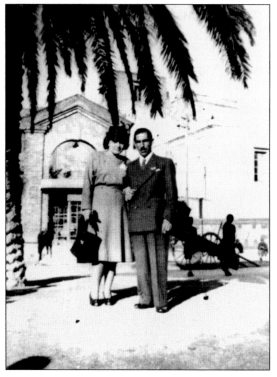

The wedding of Giovanna Martelli and Giovanni Francesco Rettura was held at the Cathedral of Nicastro, Calabria (seen here in the background), on December 5, 1946. As an Italian prisoner of war during World War II, Giovanni was held captive at Camp Shank in Brooklyn, New York. While in captivity, Giovanni was visited by Giovanna, whom he had met while she was living in Italy. Giovanna had returned to northeastern Pennsylvania in 1939 because of the growing threat of war in Europe. (Courtesy of John Rettura.)

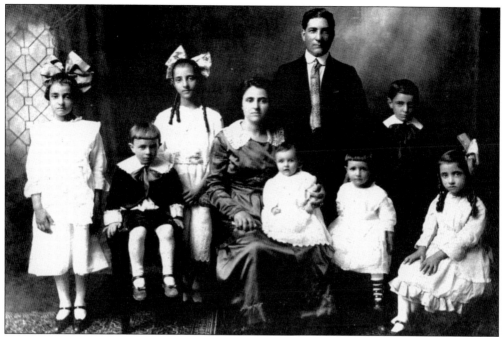

This 1920 photograph shows the John Cerra family of Hospital Street in Carbondale. From left to right are the following: (first row) Dennis Cerra, Mary Scalzo Cerra, Fernata Cerra Gillott, Rose Cerra Motsay, and Carmelita Cerra Farber; (second row) Helen Cerra, Madeline Cerra, John Cerra, and Angelo Cerra. (Courtesy of Evelyn Pettinato.)

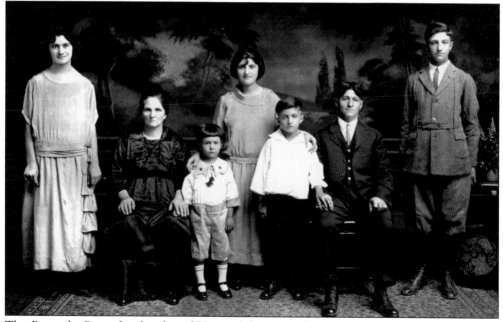

The Pasquale Cerra family, also of Hospital Street in Carbondale, was related to the John Cerra family. Shown from left to right are Rose Cerra Pascoe, Francesca De Fazio Cerra, Patrick Cerra, Jennie Cerra Carline, Bernard Cerra, Pasquale Cerra, and Louis Cerra. (Courtesy of Joe Pascoe.)

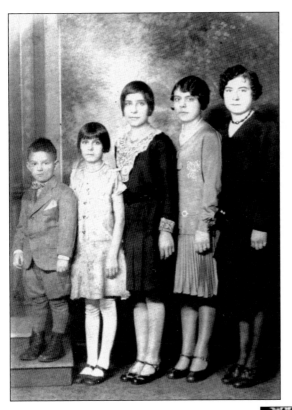

This photograph shows the Bertinelli and Galli children of Jessup. Pictured from left to right are Ferruccio Bertinelli, Marsilia Galli, Santina Galli, Angeline Galli, and Anna Galli. (Courtesy of Joan Ondush.)

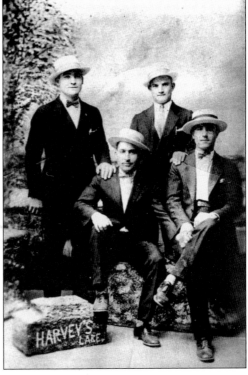

These immigrants, originally from Nocera Umbra, worked as miners in Pittston. Here, in 1921, they spend the day at nearby Harvey's Lake, a popular spot for relaxing, away from the daily trials and tribulations of the coal mines. (Courtesy of the Museo Regionale dell'Emigrazione of Gualdo Tadino, Italy.)

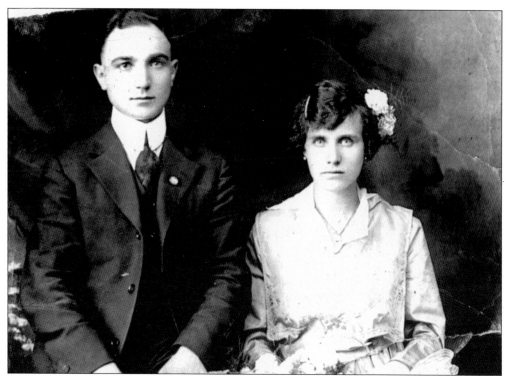

Francesco and Francesca Gialanella traveled from Guardia dei Lombardi, Campania, to Dunmore in 1914. This image depicts their wedding day, on October 4, 1914, at St. Rocco's Church. The family name was later changed to Genello. (Courtesy of Carlo Pisa.)

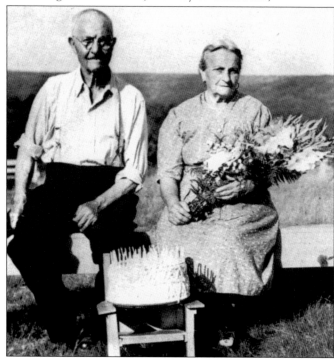

Luigi and Margherita Marianelli, seen here in 1933, were immigrants to Old Forge from Sigillo, Umbria. Margherita was celebrating her birthday, possibly her first in the United States. (Courtesy of the Museo dell'Emigrazione of Gualdo Tadino, Italy.)

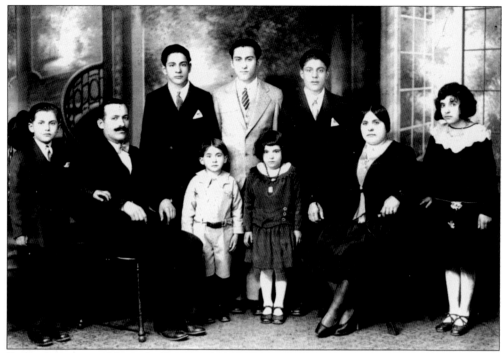

Ottavo Massetti and his wife, Erminia Carboni Massetti, pose in 1930 with their children, from left to right, Thomas, Joseph, August, John, Louise, Amerigo, and Florence. Ottavo came to the United States in 1909 from Arezzo, Tuscany, and Erminia followed him a year later. The couple settled in Jessup and Lake Ariel. (Courtesy of Richard Palermo.)

Taken in 1924 in San Cataldo, Sicily, this photograph shows Vincent Palermo and his wife, Anna Panzica Palermo, with their sons Frank, Samuel, Joseph, and Ross. The Palermos left Italy to escape fascism, but were refused entry at Ellis Island because Anna had vision problems. Instead of returning to Italy, however, they entered the United States through Canada. The Palermos went to Throop upon arrival, but later moved to Dunmore, where they sold produce. Three other children were born in the United States: Carmella, Mary, and Arthur. (Courtesy of Richard Palermo.)

Three

FORZA ED AVANTI

Forza ed avanti, "Be strong and go forward," is the oft-repeated phrase used by Italians to give encouragement in a difficult situation. No situation could have been more difficult for a newly arrived Italian immigrant than the discrimination of which they were constant victims simply because they were Italian. This discrimination was a direct result of the pre-established immigrants' (the Welsh, Irish, and Germans) mistrust of the Italians because of their different dress, worship, and culture. The fact the Italian language was so far from the English language did not help the Italians in their quest to become accepted in American society.

Anti-Italian sentiment was also apparent in northeastern Pennsylvania. For example, the sisters of St. Lucy's Parish in Scranton received an anonymous note in 1907 that stated, "We give you and the priest [Fr. Dominic Landro] three days to leave, but if you refuse, after that the house and the church will be blown up with dynamite." The *Scranton Times* felt that this was the work of a mafia-esque organization and wrote: "In the interest of peace and law abiding citizenship, the suggestion is here made to Mayor Dimmick that he institute an early and effective police raid upon Italians who go about loaded down with knives, stilettos, and revolvers. There are many thoroughly good Italian people in Scranton, but there are also a large number who know not what the meaning of liberty is and the minute they set foot in this country and get enough money to visit a hardware store, one of their first purchases is a deadly weapon, and it is prized as one of their closest possessions" (*Scranton Times*, April 25, 1907).

Yet, through their actions, the Italians of northeastern Pennsylvania and others throughout the country have consistently shown that they are strong and able to move forward, despite the difficulties they faced during their early days in the United States. For example, Andrew Sordoni of Luzerne County, the first Italian-American to serve as Pennsylvania state senator, labored as a mule driver in the coal mines as a youth (Scott 1973, 18). Evidently, many immigrants worked their way up from the poorest of the poor to being some of the area's most prominent and honored Italian-American citizens.

In 1889, Amedeo Obici, then 12 years old, left his home in Oderzo, Veneto, to join family in Scranton. At the age of 20, he decided to start his own business by selling 5¢ bags of roasted peanuts. He paid $4.50 for a peanut roaster operated by an old electric-fan motor rigged to a set of pulleys. This peanut roaster was the very first in a series of roasters that eventually became Planters Nut and Chocolate Company of Wilkes-Barre, a company that Obici founded along with Mario Peruzzi of Hazleton. Mr. Peanut, the mascot of Planters, was also designed by an Italian from northeastern Pennsylvania: a 14-year-old boy named Antonio Gentile. (Courtesy of the National Italian American Foundation.)

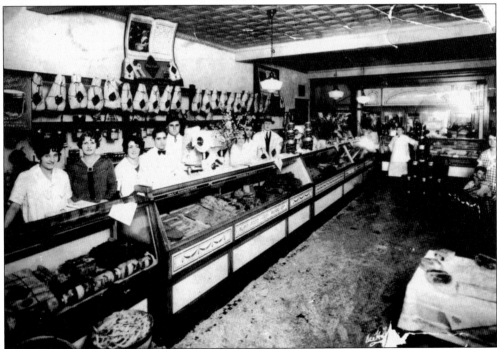

One of the stores where Planters peanuts were sold was Giuseppe Campanella's food store, located in Wilkes-Barre. Campanella emigrated from Gualdo Tadino, Umbria, with his family to northeastern Pennsylvania during the second decade of the 20th century. (Courtesy of the Museo Regionale dell'Emigrazione, Gualdo Tadino, Italy.)

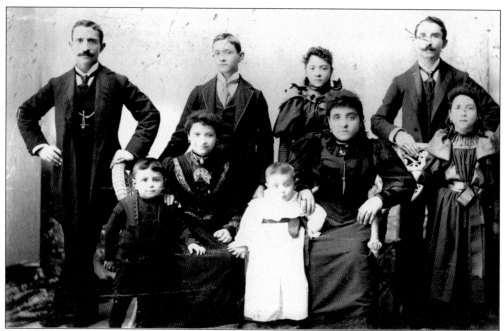

Gabriel Pugliano was an avid supporter of his fellow Italians. In a speech at a supper in honor of the Carbondale Agents of Chase and Sanborn on July 7, 1899, Pugliano stated that "[the Italians] are not only dutiful and good working men, but also faithful and obedient to their employer." In this photograph, Pugliano is seen with the rest of his family. Pictured from left to right are the following: (first row) Gabriel Pugliano Jr., Henrietta Pugliano Moro, Violet Pugliano Mussari, Mrs. Gabriel Pugliano, and Elvira Pugliano Talarico; (second row) Gabriel Pugliano, unidentified, Loretta Pugliano, and Santo Pugliano. (Courtesy of Anthony Talarico.)

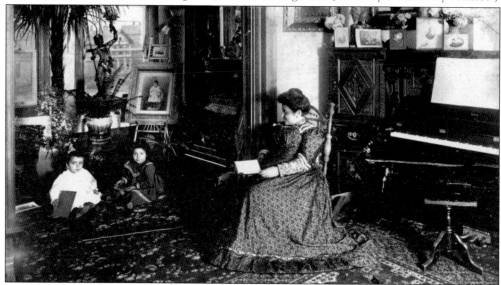

The Puglianos belong to a fortunate group of Italian immigrants who found wealth and success, as evidenced here in the living room of the family home in Carbondale. Seen from left to right are Gabriel Pugliano Jr., Violet Pugliano Mussari, and Mrs. Gabriel Pugliano. (Courtesy of Anthony Talarico.)

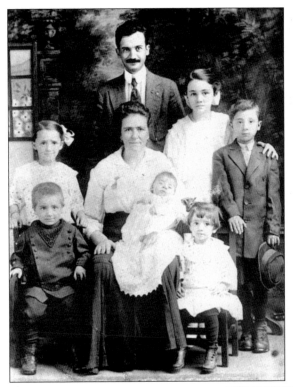

Salvatore Mascaro, born in Nicastro, Calabria, immigrated to the United States in the early 1900s, becoming a prominent shoemaker in the South Side of Scranton until his death in 1946. A member of Lodge No. 534 of the Order of the Sons of Italy in America, he always wore a pin in the shape of the Italian peninsula on his lapel. In this photograph, he is seen with his wife, Francesca La Scala Mascaro, and their children, who are, from left to right, as follows: (first row) Joseph, Anthony, and Anna; (second row) Theresa, Mary, and Thomas. The Mascaros also had another child named Robert. (Courtesy of Carmella Bennett.)

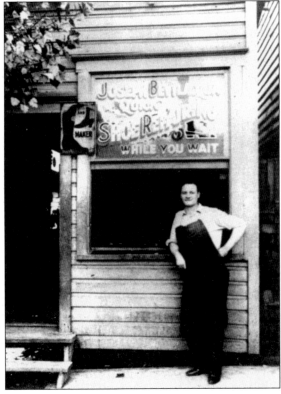

In 1930, shoemaker Joseph Bevilacqua from Gubbio, Umbria, stands in front of his Jessup shop, which advertised "quick repairs while you wait." (Courtesy of the Museo Regionale dell'Emigrazione, Gualdo Tadino, Italy.)

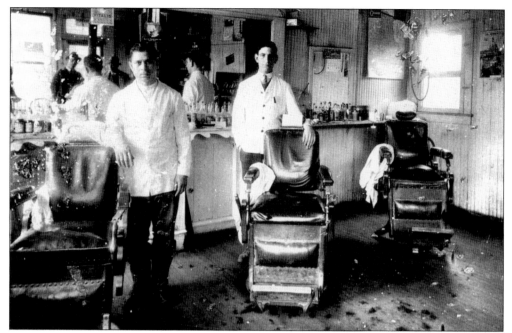

This photograph was taken in December 1920 at the Galati family barbershop in Carbondale. At the first chair is Joseph Galati, and at the second chair is Victor Penzone. Joseph Galati started the barbershop on Hospital Street in Carbondale in 1917, and three years later, he moved it to its present location at 15 Salem Avenue in Carbondale. (Courtesy of Galati's Barbershop.)

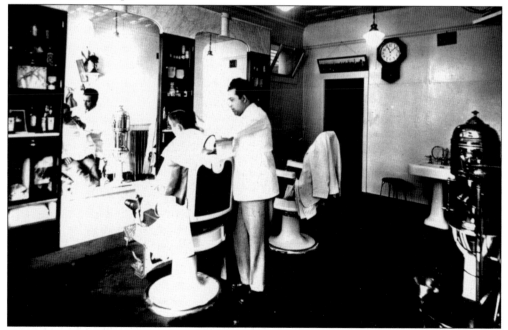

Here, Leonardo Alfredo Daniele works in his Williamsport barbershop in July 1929. Daniele was born in Bovino, Puglia, Italy, in 1895 and passed away in 1963 in Williamsport. (Courtesy of Joanna Daniele.)

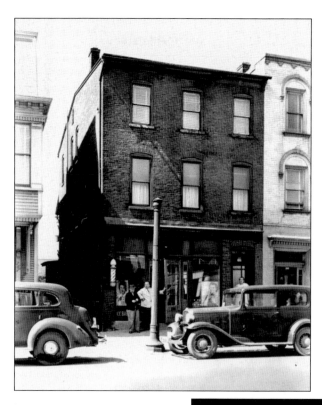

The outside of Leonardo Alfredo Daniele's barbershop is seen here *c.* 1947. It was located at 149 Market Street in Williamsport's Little Hollywood section, also known as the Italian section. Tradition states that the section was named Little Hollywood because some of the Italian boys who lived there were so handsome that they reminded people of movie stars. Pictured from left to right are Frank DeGregorio, Leonardo Alfredo Daniele, and Rosa Pasinello. (Courtesy of Joanna Daniele.)

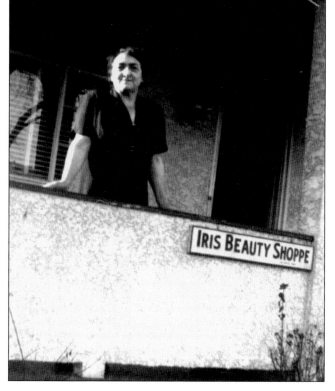

Stella Pericoli Righi stands on the porch of her daughter Iris's beauty shop in South Scranton. Stella worked as a seamstress and made all the clothes for her family. Iris received her beautician's license while she was in her mid-20s and established her shop right inside of the family home. (Courtesy of Ron Refice.)

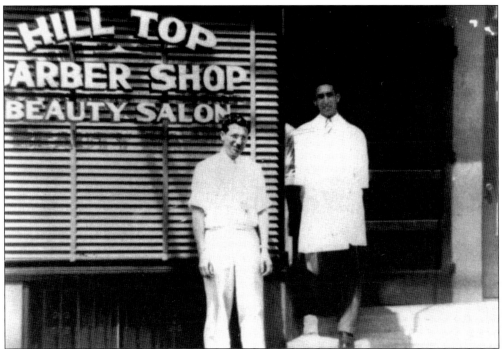

Joe Longo (right) stands with one of his friends outside the Hill Top Barber Shop in the Petersburg section of Scranton. Joe emigrated from Guardia dei Lombardi, Campania, at the age of 11 and began to work in his brother Gaetano's barbershop at the age of 12, learning his trade while he worked. The Hill Top Barbershop was Joe's first job as a barber after receiving his license. (Courtesy of Ann Marie Longo.)

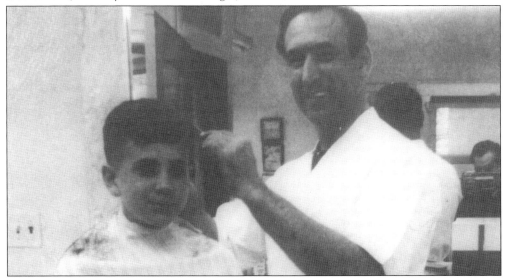

Here, Joe cuts his nephew John Paul's hair at the Bull's Head Barbershop in the Bull's Head section of Scranton. Joe owned and operated several barbershops in the Scranton and Dunmore areas from the 1930s until his retirement in the 1970s. The Bull's Head Barbershop was his most popular shop, with customers arriving as early as 7 a.m. and as late as 9 p.m. just to have him cut their hair. (Courtesy of Ann Marie Longo.)

Amanzio "Mimi" Trovato and his brother Carmelo owned and operated Trovato Brothers Meat Market at 919 Scranton Street in the West Side of Scranton. The Trovatos emigrated from Casalvecchio Sciulo, Sicily, to Hazleton, then moved to Scranton in the early 1900s. In the early 1950s, Carmelo and Amanzio separated their business, and the store was simply called Trovato's Market. (Courtesy of John Trovato.)

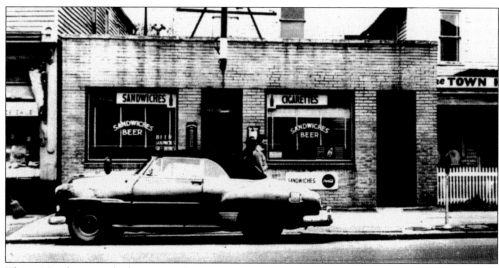

This 1952 photograph shows Gambini's Bar in Jessup, which was owned by Antonio Gambini, whose parents had emigrated from Gubbio, Umbria, to Jessup several decades before. (Courtesy of the Museo Regionale dell'Emigrazione, Gualdo Tadino, Italy.)

While their husbands are at work in the apple orchards at the Mid-Valley Farm Dairy in South Canaan, Lillian Portanova (left) and Santina Galli Coccodrilli (right) prepare lunch for their break, as seen in this 1940s photograph. (Courtesy of Joan Ondush.)

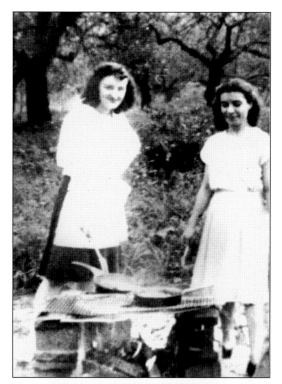

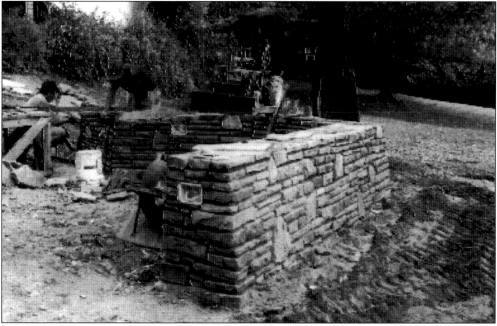

Felix "Phil" Di Rienzo (seen in background) worked as a bricklayer, stonecutter, and stonemason until his retirement in the 1980s. He learned his trade from his father, Stephen. Both Felix and Stephen worked on many of the well-known buildings in Scranton, including St. Ann's Basilica and the Lackawanna County Courthouse. Stephen Di Rienzo had a popular construction business that, unfortunately, was lost during the Great Depression. (Courtesy of the Di Rienzo Family.)

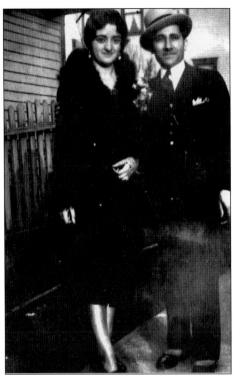

Emil and Theresa Calomino both labored hard to support their family. Emil was a chef at the Purple Cow and the Hotel Jermyn in downtown Scranton, and Theresa worked in a glove factory located on Apple Street in Dunmore. (Courtesy of Carmella Bennett.)

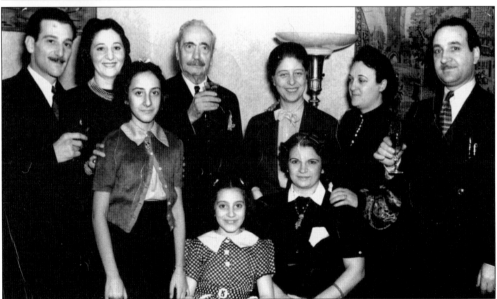

Few people realize that northeastern Pennsylvania holds a special distinction with the Italian government: it is the site of an honorary consulate to the Republic of Italy because of its abundance of Italian immigrants. Fortunato Tiscar (the elderly gentleman holding the wine glass in the back row) was the very first Italian consul to Scranton, which is where the consulate has always been located. Tiscar served in this position from 1896 to 1941. Tiscar is pictured here with members of the Fiorani family of Scranton and some friends from Italy. (Courtesy of Rosemary Fiorani Gallagher.)

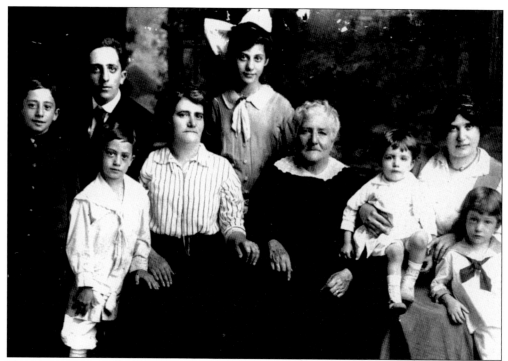

The Floreys, originally from Porgeto, Sicily, owned a family grocery store in Scranton's West Side, where they gave away food and other items to help newly arrived Italian immigrants. The Floreys were also one of the charter members of St. Ann's Monastery in Scranton's West Side. The young girl with the bow in her hair is Rose Florey Fiorani (see below), who was to become one of northeastern Pennsylvania's most prominent Italian-Americans, along with her husband, Angelo. (Courtesy of Rosemary Fiorani Gallagher.)

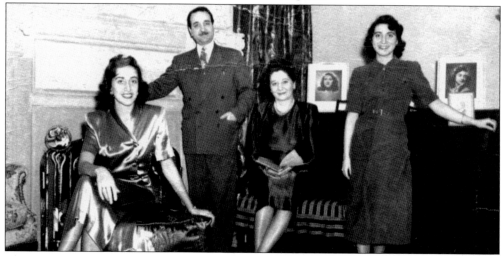

The Fioranis gather at their home in Scranton in 1949. Pictured from left to right are Eleanor, Angelo, Rose, and Rosemary. Rose and Angelo Fiorani were involved with community service in Scranton and its surrounding areas, especially during World War II. After the war, the Italian government awarded them the Star of Solidarity for helping with the reconstruction effort in Italy. (Courtesy of Rosemary Fiorani Gallagher.)

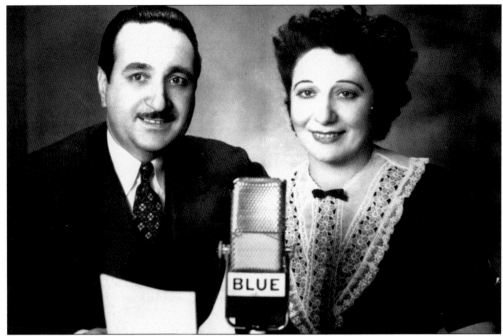

Rose and Angelo Fiorani were best known as the owners of WPTS radio in Pittston. From 1933 to 1975, they provided Italian-language programming to those in the Scranton and Wilkes-Barre area who could not understand English. Italian music was played by a live orchestra and through recordings. Italian sketches were done by electrical transcriptions. The Fioranis' first radio program was Fiorani's Shopping Guide, which helped newly arrived immigrants assimilate into American culture by telling them where to shop. (Courtesy of Rosemary Fiorani Gallagher.)

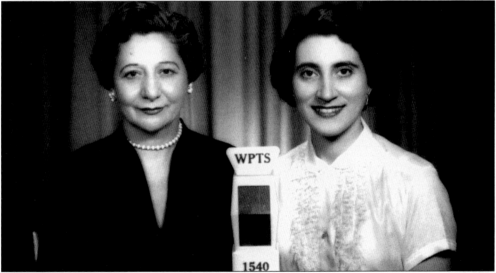

After Angelo Fiorani's retirement from radio, the Fioranis' daughter, Rosemary, assumed control. Rosemary is currently dedicated to preserving her parents' legacy; she has donated a large number of their recordings to the Balch Institute of the Historical Society of Pennsylvania in Philadelphia, which documents America's ethnic history. (Courtesy of Rosemary Fiorani Gallagher.)

Rose and Angelo Fiorani were named Knight and Lady of the Holy Sepulcher by the Vatican in 1960, in a ceremony at St. Patrick's Cathedral in New York City. They received the award from Cardinal Francis Spellman, then archbishop of New York. The mission of the Order of the Holy Sepulcher is to reinforce the practice of Christian life and to assist with all works of the Catholic Church in the Holy Land. (Courtesy of Rosemary Fiorani Gallagher.)

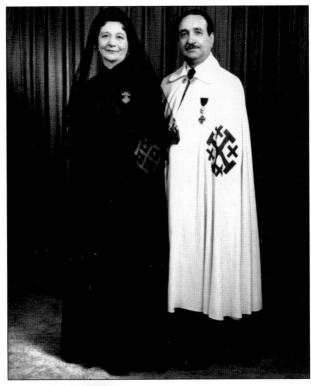

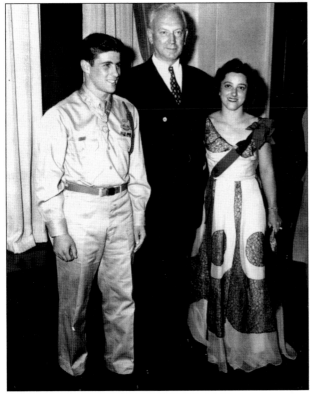

Bringing Italian culture to northeastern Pennsylvania, Rose and Angelo Fiorani planned opera performances at the Masonic Temple (now the Scranton Cultural Center) in downtown Scranton. Lillian Ventimiglia Raymondi (right), seen here with Gino Merli (left) and Pennsylvania governor Edward Martin (center) in the 1940s, was born in Scranton and became a singer at the Metropolitan Opera House in New York City. She was most noted for her role as Papagena in Mozart's *The Magic Flute*. (Courtesy of Mary Lemoncelli Merli.)

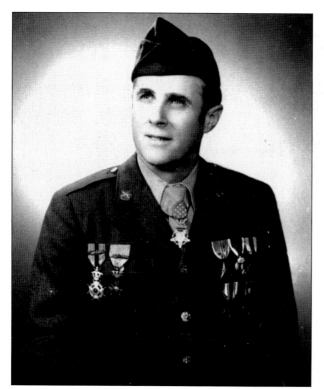

Gino Merli of Peckville earned the Medal of Honor in 1945 for his bravery during World War II at Sars-la-Bruyère, Belgium. After faking his own death several times to defend against the Germans, he learned that the American forces had succeeded in their counteroffensive and that the Germans had asked for a truce. He then requested permission to go to a nearby chapel and pray for the souls of every soldier—enemy or ally—who was killed during the battle. (Courtesy of Mary Lemoncelli Merli.)

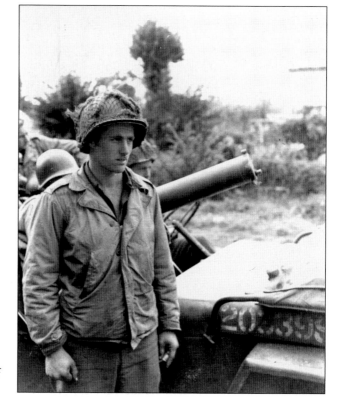

Gino Merli is seen on September 4, 1944, just a few hours after his encounter with the Germans. Merli has said about his Medal of Honor: "We all did what we had to do back then. I didn't, as the media would say, 'win' the Medal of Honor. I was not out winning anything. Like anyone else, I was doing my duty and preserving my life." (Courtesy of Mary Lemoncelli Merli.)

Gino Merli was given a hero's welcome on June 18, 1945, when he arrived home in Peckville. Seen with Merli in this *Scranton Tribune* photograph are his then sweetheart, Mary Lemoncelli, and his parents, Assunta (in the front passenger seat wearing the hat) and Egisto (in the back seat next to his son). Thousands of people lined the Blakely streets just to glimpse their hometown hero. (Courtesy of Mary Lemoncelli Merli.)

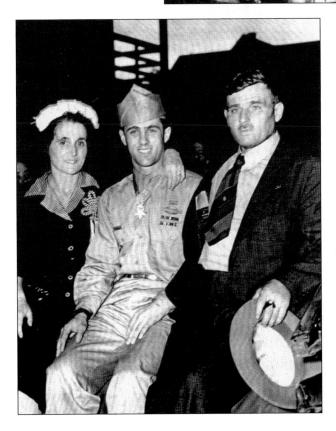

Later that afternoon, Gino Merli sat down with his parents, who had emigrated from Mondaino, Emilia-Romagna, to Scranton on January 5, 1921, to join Egisto's father. Gino Merli firmly believed in his Italian heritage, saying, "Not everyone can be a Medal of Honor recipient but everyone can have pride in himself—have pride in his heritage." This pride was the basis for Gino's nomination as Man of the Year by the Columbus Day Association of Lackawanna County in 2001. (Courtesy of Mary Lemoncelli Merli.)

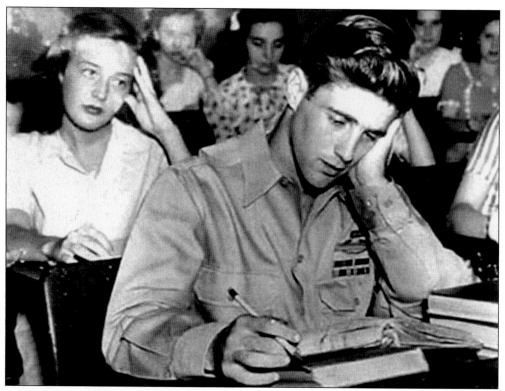

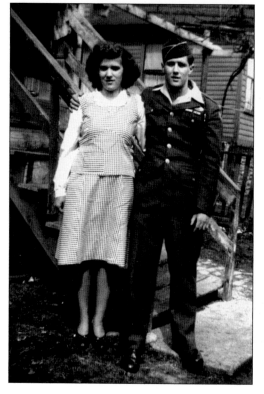

After his triumphant return home in 1945, Gino Merli completed his senior year at Blakely High School. Before going into the service, Gino had been a football player for Blakely High; upon his return, he became assistant coach for the children's football team, whom he called his "Little Midgets." (Courtesy of Mary Lemoncelli Merli.)

When Assunta and Egisto Merli immigrated to northeastern Pennsylvania, they had to leave Emma, their eldest daughter, behind to be raised by Assunta's parents. While in school, Emma had to wear a fascist black shirt as one of the *balille*, part of Benito Mussolini's special educational training for young girls. Emma arrived in the United States at age 18 and was reunited with her parents and brothers, including Gino, with whom she is seen here. (Courtesy of Mary Lemoncelli Merli.)

Mary Lemoncelli Merli was also very much involved in patriotic activities during World War II. In this photograph, she is seen with her friend Elda Mashie (left) and her dog, Pietro. She wears a U.S. Army raincoat because she frequently volunteered for the army and the USO in Eynon. Both Gino and Mary Merli were convinced that today's American youth could do what their generation did during World War II by unconditionally supporting their country's troops. (Courtesy of Mary Lemoncelli Merli.)

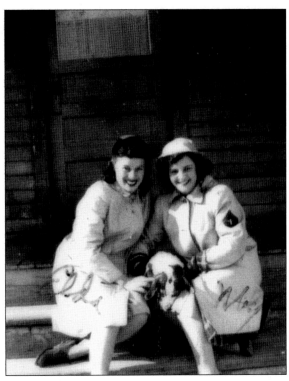

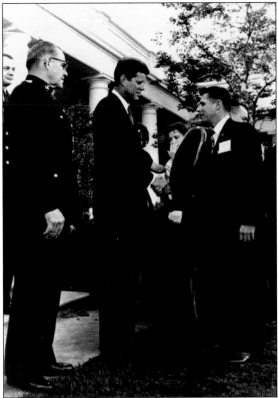

After completing high school, Gino Merli remained active in veterans' affairs by working with the Veterans Administration in Wilkes-Barre and by going to Washington, D.C., to advocate for veterans' needs. Here, he shakes the hand of Pres. John F. Kennedy in 1962. (Courtesy of Mary Lemoncelli Merli.)

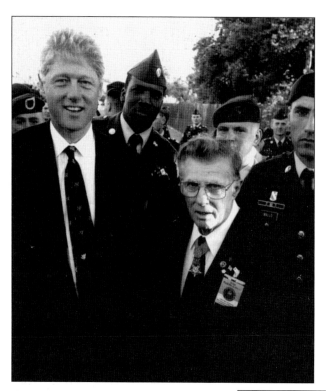

In his later years, Gino Merli dedicated himself to teaching young people about the lessons of war through his work with the Congressional Medal of Honor Society. He was also active in promoting the need for the World War II Memorial on the National Mall in Washington, D.C. Here, Merli meets with Pres. Bill Clinton while visiting Washington, D.C., with other veterans and active-duty soldiers. (Courtesy of Mary Lemoncelli Merli.)

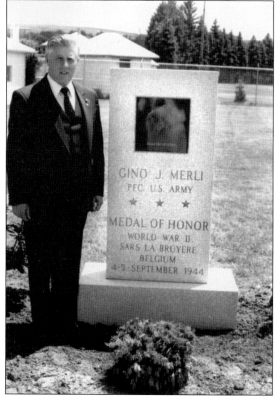

Gino Merli, seen here next to a Peckville monument dedicated in his honor, will always be remembered by the residents of northeastern Pennsylvania. He enjoyed the simple things in life, especially the pear tree that he planted in his backyard. Above all, Gino Merli was proud of his country, saying, "To me, patriotism means love of God, country, and freedom—a nation of united people." He passed away on June 11, 2002, right under his pear tree. (Courtesy of Mary Lemoncelli Merli.)

Many Italian immigrants and their children joined the American armed forces upon gaining United States citizenship. This photograph shows Lindo Staffaroni of Carbondale in his U.S. Marines uniform in 1934. Lindo's father, Luigi Staffaroni, was born in Sigillo, Umbria. (Courtesy of the Museo Regionale dell'Emigrazione of Gualdo Tadino, Italy.)

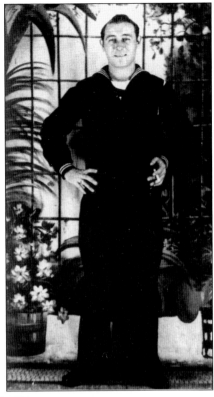

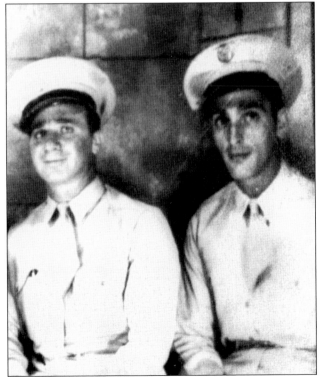

Americo "Eddie" Refice (right) and his friend Jake Piloti of Scranton were both drafted into the U.S. Army in 1943 and served during World War II. Eddie served in the Cook and Baker Corps and, after the war, joked that his superiors liked his cooking so much that he entered the war as a private and left as a sergeant. (Courtesy of Ron Refice.)

Perhaps one of the saddest stories to come out of World War II is that of the Cerra and Leo families of 53 Leo Street in Carbondale. Pictured above are, from left to right, brothers Felix and Joseph Cerra and their first cousins, brothers Joseph and Samuel Leo. All four men were killed in action while fighting overseas. Today they are remembered on a monument at the Cerra-Leo Memorial Park, named in their honor, in Carbondale. (Courtesy of Andrew Cerra.)

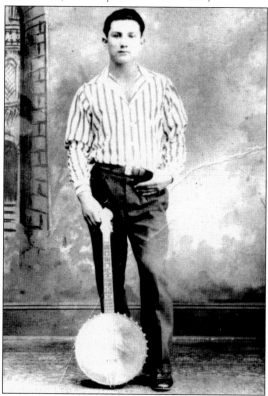

At 17 years old, Joseph Luongo of Scranton's Bunker Hill section was already an accomplished musician. He was an electrician, but his passion was music—a passion he passed on to his children, with whom he performed as the Luongo Family. When his son Pat was five years old in the 1940s, the two appeared on Maj. Edward Bowes's "Original Amateur Hour" on CBS. Joseph Luongo's parents, Patsy and Pauline Luongo, had emigrated from Guardia dei Lombardi, Campania, in the early 1900s. (Courtesy of Joe Luongo and Pauline "Pudgy" Luongo Stivala.)

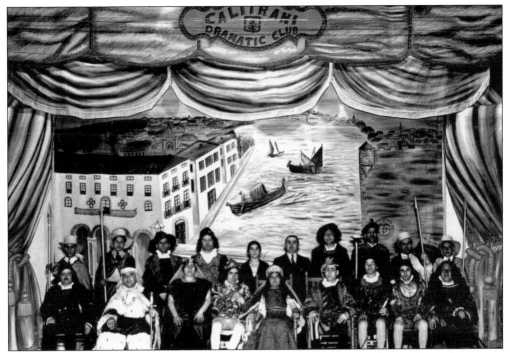

The Calitrani Dramatic Club of Dunmore, comprised of immigrants from Calitri, Campania, performed dramatic plays in Italian for newly arrived immigrants. This c. 1925 photograph shows members dressed in Shakespearean costume after putting on *The Merchant of Venice*. (Courtesy of Rosemary De Maio Fariel.)

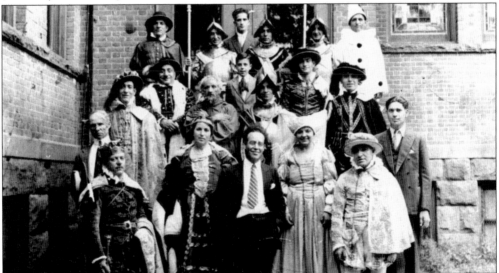

After a c. 1930 performance, Calitrani Dramatic Club members assemble outside. Pictured from left to right are the following: (first row) Paul De Muro, Silvio Vitaletti, and Chris Zabatta; (second row) Albert Calomino, Vincenza De Maio, Antoinette Margotta, and Anthony Cantarella; (third row) ? Zabatta, ? De Muro, ? Rinaldi, and Jane Strollo; (fourth row) Giovanni De Maio, Michael Penetar, and Joseph Margotta; (fifth row) Bill Rinaldi, ? De Pietro, Sal Rubino, Jim Nicholas, Jim Martinelli, and unidentified. (Courtesy of Rosemary De Maio Fariel.)

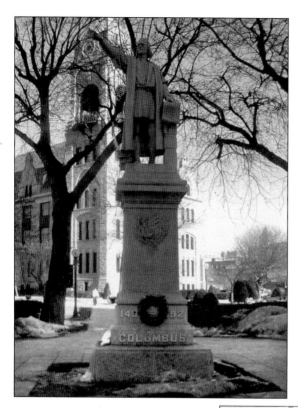

This monument to Christopher Columbus, the first statue to be placed on Scranton's Courthouse Square, was dedicated on October 21, 1892, immediately after the city's first Columbus Day celebration. The monument was funded by residents of Italian birth or extraction and was supposed to have been dedicated on October 12, 1892, the 400th anniversary of Columbus's discovery of the New World. But because a monument base was difficult to find, the unveiling was delayed. (Photograph by Stephanie Longo.)

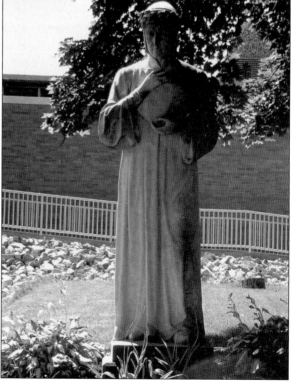

Another monument funded and donated by the Italians of Scranton is this statue of Dante, which now stands in front of Alumni Memorial Hall at the University of Scranton. Formerly located at Platt Place and Jefferson Avenue, it was moved when the Spruce Street Complex was built. Scranton sculptor Agostino N. Russo brought this statue from Italy to Scranton in 1922; it was formally donated to the city in 1923. (Photograph by Stephanie Longo.)

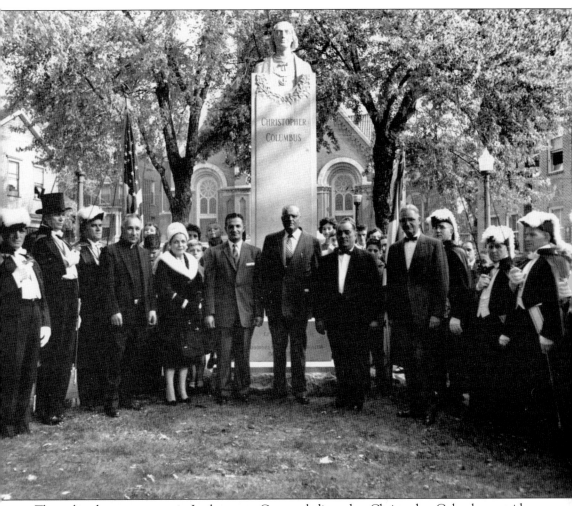

The only other monument in Lackawanna County dedicated to Christopher Columbus outside of Scranton is this one in Carbondale. The Carbondale Columbus Monument was dedicated on October 11, 1959, in Memorial Park, where it can still be seen today. (Courtesy of Joe Pascoe.)

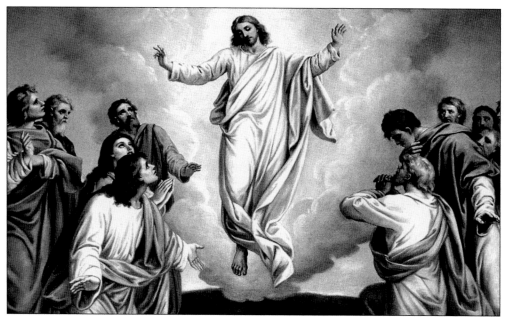

The name Gonippo Raggi is synonymous with some of the finest artwork in Scranton. These images were taken from the rotunda at Marywood University's Liberal Arts Center. Mother Josepha Hurley, the fourth president of Marywood, commissioned Raggi to paint the interior of the rotunda in 1935. Raggi was born and schooled in Rome, Italy, and upon arrival in the United States, lived in East Orange, New Jersey, while working for the Anthony Pace Studios in New York City. Carpenters from Scranton's Nay Aug Lumber assisted Raggi in the Marywood project. Above can be seen a painting of the Ascension of Jesus into heaven, which is on the first floor of the Liberal Arts Center rotunda. At right is a painting of St. Cecilia, patron saint of musicians, surrounded by angels, which is on the second floor of the rotunda. (Photographs by Stephanie Longo.)

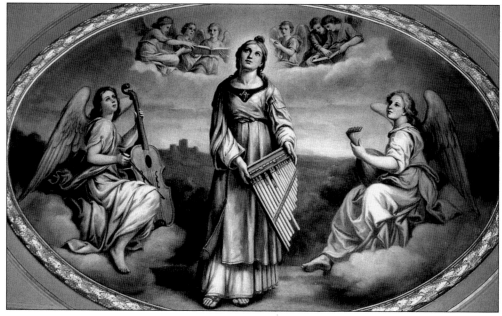

Four

LA SANTA CHIESA

The Catholic Church, *la Santa Chiesa,* has always exercised a heavy influence on the lives of Italians and Italian-Americans. The Republic of Italy's population is more than 95% Catholic, and Roman Catholicism has been declared the country's official religion. In the days before the *Risorgimento,* the Catholic priest was regarded as the most important member of the community, sometimes even more important than the mayor.

The Italians who immigrated to the United States brought their brand of Catholicism with them, but they were soon met with resistance. The American Catholic Church at the turn of the 20th century was dominated by the Irish, who had arrived in the United States a generation before (Gambino 1996, 235). The beliefs and practices of the Italians puzzled and shocked the Irish, who felt that the Italian Catholic Church was pagan in its rituals, especially in how it worshiped the Blessed Virgin Mary. Italian Catholics avoided sending their children to Catholic schools as they had done in Italy, because the Irish priests and nuns were not sympathetic to their children's difficulties with the English language (Grifo and Noto 1990, 15). In an attempt to preserve their own traditions and brand of Catholicism, many Italian communities decided to establish their own parishes.

The Diocese of Scranton, which encompasses all of northeastern Pennsylvania, includes more than 30 Italian Catholic parishes. About 60 Italian parishes are in the Commonwealth of Pennsylvania, and the Diocese of Scranton has more of these parishes than either the Archdiocese of Philadelphia or the Diocese of Pittsburgh. Interestingly, Philadelphia and Pittsburgh are the two cities in Pennsylvania with the largest Italian populations (Grifo and Noto 1990, 14). A possible explanation for this large number of parishes in the Diocese of Scranton could be attributed to the fact that the Italians who arrived there came from a variety of towns, provinces, and regions in Italy. *Campanilismo,* or the Italian's pride in his or her hometown, was still strong. A Neapolitan would not want to attend Mass with a Sicilian, or vice versa.

Italian Protestant churches also existed in northeastern Pennsylvania. Many Italians came over as Protestants, but Protestant missionaries also worked to convert Italian immigrants away from Catholicism in order to facilitate their assimilation into American society. Some Italian Protestant churches still remain in northeastern Pennsylvania, such as the Italian Presbyterian (also known as Second Presbyterian) Church in Pittston and the Italian (also known as Christian) Assembly in Wilkes-Barre.

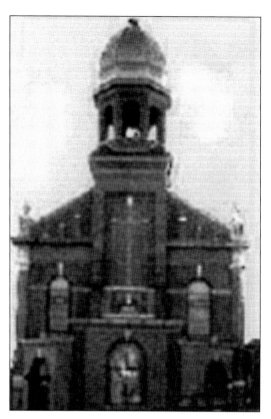

One of the very first Italian Catholic churches established in the United States was the Church of the Most Precious Blood, founded in Hazleton in 1885. This photograph is derived from a vintage postcard from the 1940s.

Monsignor Francis Fedele Molino was born in Asti, Piedmont, on February 26, 1877, and celebrated the diamond jubilee (60th anniversary) of his priesthood while pastor of the Most Precious Blood Church in Hazleton in 1962. Monsignor Molino succeeded in inviting tenor Beniamino Gigli to Hazleton to perform in 1928 and in sending a group of seven Italian-American boys to Italy as guests of the Italian government for cultural benefits in 1935. (Courtesy of Our Lady of Mt. Carmel Parish.)

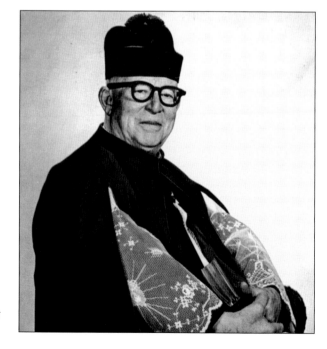

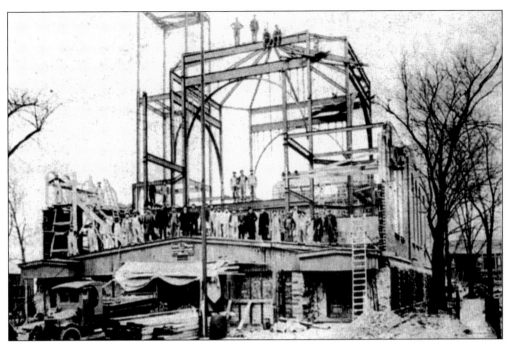

The new St. Lucy's Parish is under construction on January 19, 1924, in the West Side of Scranton. St. Lucy's was the first Italian parish in Lackawanna County, established in 1891 by Rev. Rosario Naco. The former Scranton Public School 16 was used as a sanctuary and school until 1913, when Rev. Victor Giurisatti erected the foundation for a church. The new St. Lucy's was constructed by the Louis Caputo Company, also of Scranton. (Courtesy of St. Lucy's Parish.)

This photograph shows how St. Lucy's looked after completion in 1928. Today, the church no longer bears the bell tower seen on the left; it was removed in 1956 due to caving caused by the deterioration of underground timbers from the city's coal-mining days. The Diocese of Scranton felt that removing the bell tower, as well as the church's 10-foot marble pulpit, would save the structure from future problems. (Courtesy of St. Lucy's Parish.)

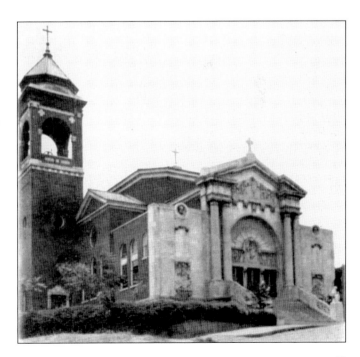

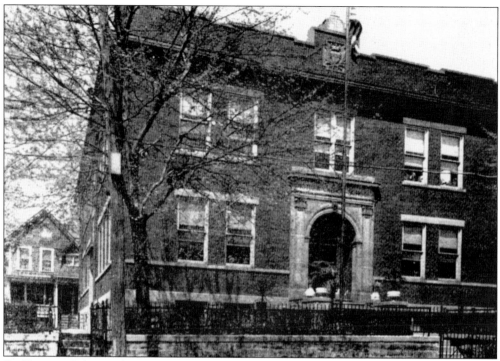

St. Frances Cabrini, the patron saint of immigrants, was the first American citizen to be canonized a Roman Catholic saint. She was a frequent visitor to Scranton in order to establish Italian Catholic missions, staying at the Cassese House on Clay Avenue. The St. Frances Cabrini School, part of St. Lucy's Parish, was located across the street from the church. Mother Cabrini personally came to Scranton in 1901 to found this school, which was run by the Missionary Sisters of the Sacred Heart, the religious order founded by Mother Cabrini, until its closing in the 1970s. (Courtesy of St. Lucy's Parish.)

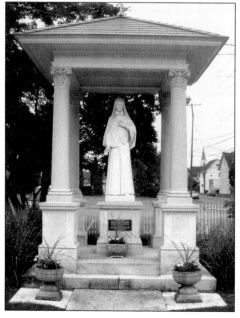

This statue of St. Frances Cabrini once stood on the grounds of the school seen above, which has since been torn down. It is now housed on the grounds of St. Lucy's Parish in a shrine honoring the saint. (Photograph by Stephanie Longo.)

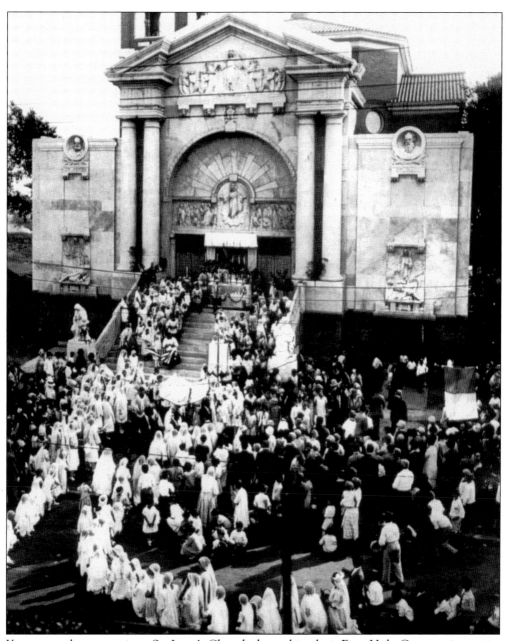

Young people process into St. Lucy's Church dressed in their First Holy Communion attire *c.* 1930. The façade of St. Lucy's was designed by Lawrence Russoniello Sr. The façade shows two scenes from World War I: one of an injured American soldier and the other of an injured Italian soldier. In each scene, an angel stands watch over the fallen soldier. (Courtesy of St. Lucy's Parish.)

Monsignor Francis Valverde was pastor of St. Lucy's Parish from 1928 to 1938. Upon his ordination to the priesthood on December 23, 1899, he served as tutor for the Italian royal family until his return to the United States. (Courtesy of St. Lucy's Parish.)

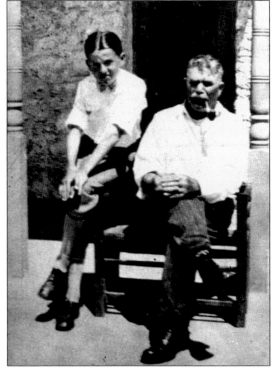

Rev. Paul Pavese (left) appears with his father, Rocco, in the 1920s. The Pavese family emigrated from Anzi, Basilicata, to Hazleton during the 1900s. Father Pavese attended the Oblate Major Seminary in Asti, Piedmont, where he was ordained to the priesthood in St. Joseph's Shrine on April 19, 1942. He recently retired after more than 60 years in service to parishioners. His last assignment was as pastor of Our Lady of Mt. Carmel Parish in Pittston. (Courtesy of Our Lady of Mt. Carmel Parish.)

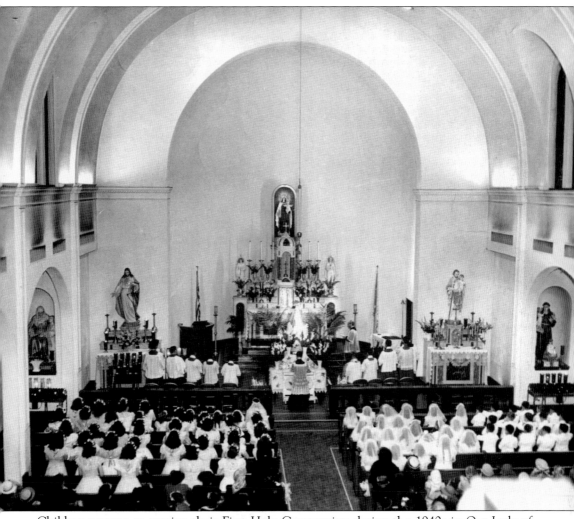

Children prepare to receive their First Holy Communion during the 1940s in Our Lady of Mt. Carmel Parish in Pittston, which was founded in 1904 by Italian immigrants. The majority of the parishioners can trace their ancestry to Campania, Puglia, and Umbria. (Courtesy of Our Lady of Mt. Carmel Parish.)

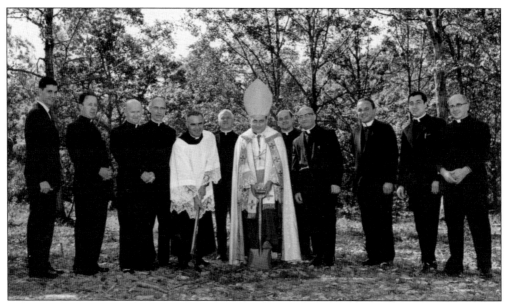

Groundbreaking for St. Joseph's Oblate Seminary in Pittston occurred on October 9, 1963. Oblate Bishop Armando Cirio from Cascavel, Brazil, holds the shovel and readies to dig into the ground. The Oblates of St. Joseph came to northeastern Pennsylvania in 1929 at the request of Bishop Thomas O'Reilly to minister to the Italian-speaking immigrants. Currently, the Oblates are the spiritual leaders of the three Italian parishes in the Greater Pittston area: Our Lady of Mt. Carmel, St. Anthony of Padua, and St. Rocco's. (Courtesy of Our Lady of Mt. Carmel Parish.)

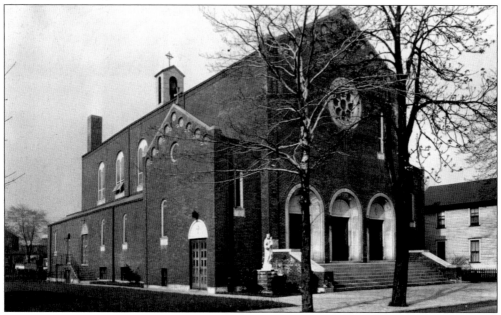

In 1940, the original Our Lady of Mt. Carmel Church burned down and the new church, pictured here, was built one block east of the original location. The church had to close again five years later due to serious damage from an underground mine subsidence. The first pastor was Rev. Eugene Gherlone. (Courtesy of Our Lady of Mt. Carmel Parish.)

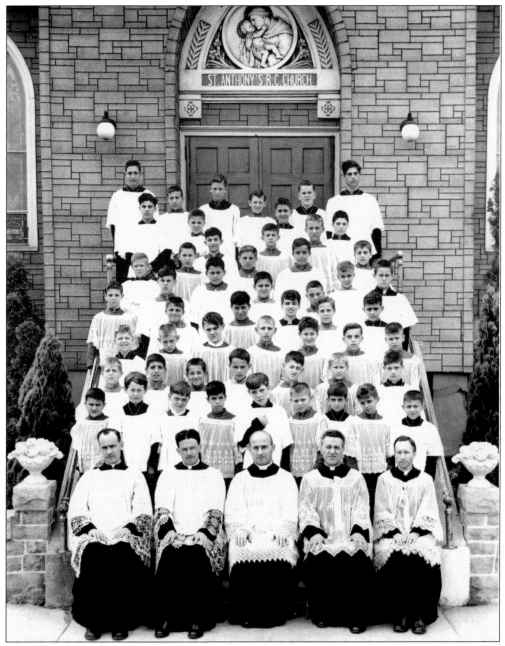

Altar boys and priests gather in front of St. Anthony of Padua Parish in Exeter c. 1950. This photograph shows the original parish, which has since been torn down. (Courtesy of Our Lady of Mt. Carmel Parish.)

St. Anthony of Padua Parish was founded on June 13, 1928, in Exeter. The Italian immigrants on the west side of the Susquehanna River wished to have their own church. They organized, saved money, and even mortgaged their homes to buy land. This statue of St. Anthony of Padua is located outside the entrance to the new church, down the block from where the original church once stood. (Courtesy of St. Anthony of Padua Parish.)

The bell tower at the new St. Anthony of Padua Church building is dedicated to the Italian immigrants who founded and funded the original church. It was built to look like a *giglio* (or lily), a gigantic steeple-shaped structure carried around in processions to honor an Italian town's specific patron saint. The most famous *giglio* festival in the United States is held in Brooklyn, New York, in honor of St. Paulinus of Nola, Campania. (Courtesy of St. Anthony of Padua Parish.)

St. Anthony of Padua Parish, on Wood Street in Scranton, was founded in 1911 by a group of Italian immigrants who wished to have their own parish in North Scranton. Upon completion of construction in 1913, Fr. Horace Margotta was named pastor. (Courtesy of St. Anthony of Padua Parish.)

Mater Dolorosa Parish in Williamsport was founded in 1908 by Fr. Dominic Landro, the former pastor of St. Lucy's Parish in Scranton. Prior to 1908, Italian Catholics in Williamsport attended Mass at the Church of the Annunciation. Fr. Horace Margotta served as the second pastor of Mater Dolorosa and oversaw the completion of construction, before he left in 1913 to assume the pastorate of St. Anthony's. (Courtesy of Mater Dolorosa Parish.)

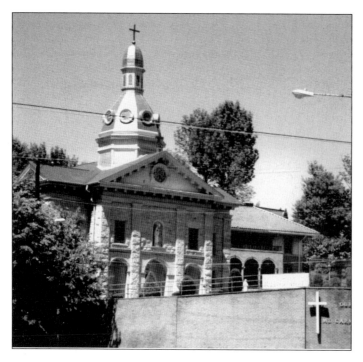

The present site of Our Lady of Mt. Carmel Parish in Carbondale was purchased on February 19, 1900, for $1,000 from the Hudson Coal Company. The church was originally a small chapel founded in 1882 on the corner of Brown and Villa Streets in Carbondale, which still stands. Our Lady of Mt. Carmel was founded by Italian immigrants who settled in Carbondale while en route to Dunmore from Rochester, New York, in search of work. (Courtesy of Sonny Cerra.)

This rare postcard shows the original St. Mary's of the Assumption Church in Old Forge. The first pastor was Rev. William Gilson, born in Udine, Friuli-Venezia-Giulia. On November 19, 1951, the original church burned down. The cornerstone for the new St. Mary's of the Assumption Church was laid on September 19, 1954. (Courtesy of St. Mary's of the Assumption Parish.)

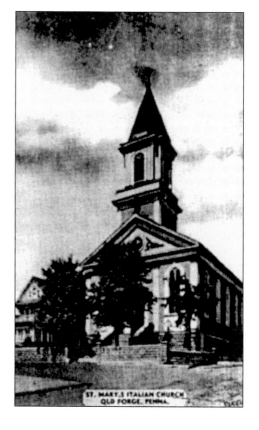

The Italian Mission of Elm Park United Methodist Church began in 1909 on Short Avenue in Scranton, and led a migratory existence until settling at the top of Lackawanna and Main Avenues in response to a growing membership. The mission conducted services in Italian for newly arrived immigrants who either came with the Methodist faith or converted upon arrival. Rev. Vincent Zaffiro was the final pastor of Elm Park's Italian Mission, which merged with Elm Park Church in 1945 upon his death. (Courtesy of Yolanda Refice.)

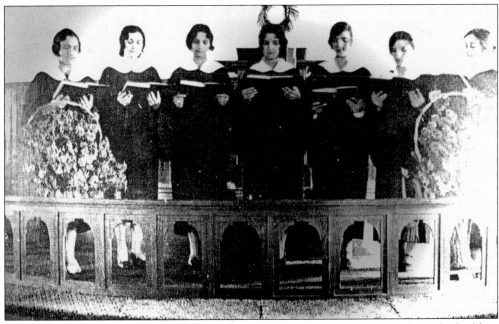

The choir of Elm Park United Methodist Church's Italian Mission is seen c. 1940. The building where the Italian Mission was once located has since been sold to the Veterans Association of West Scranton. (Courtesy of Yolanda Refice.)

St. Peter's Cathedral, the mother church of the Diocese of Scranton, has been an artistic landmark in northeastern Pennsylvania since it was built in 1865. Gonippo Raggi of Rome, Italy, painted the ceiling of the cathedral in 1934 during its renovation. The ceiling panel represented here is *Eucharist*. (Photograph by Stephanie Longo.)

The original Stations of the Cross in St. Peter's Cathedral were painted *al fresco* (on wet plaster) and were framed in glazed tile and terra cotta. In 1956, Bishop Jerome D. Hannan took photographs of the painted stations and sent them to Italy, where, again under the direction of Gonippo Raggi, mosaic stations were prepared. These new stations were installed in the frames of the originals and presented on Pentecost Sunday in 1957 as a gift to the Diocese. The station seen here is the sixth, Veronica Wiping the Face of Jesus. (Photograph by Stephanie Longo.)

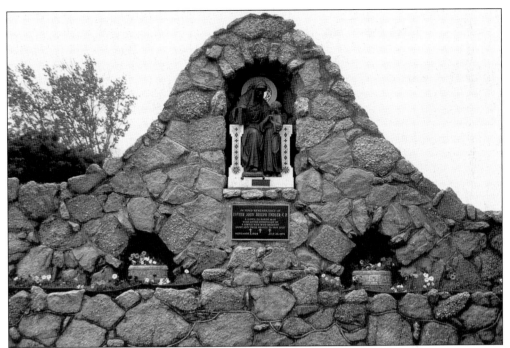

The construction of the Grotto at St. Ann's Monastery (now Basilica) in Scranton's West Side was a family affair. It was begun by Carmen Daiute, the grandfather of Dolores Petrini. During the Great Depression, stonemason Stephen Di Rienzo restored the Grotto each year because the church was located in a coal-mining cave-in zone. Stephen's son Felix restored and maintained his father's work after his retirement. Felix Di Rienzo and Dolores Petrini are married. (Photograph by Stephanie Longo.)

This prayer book, published in Italian by the Passionist Fathers of St. Ann's Basilica, is used every year for the Solemn Novena to St. Ann. On July 26, the feast day of St. Ann, the mother of the Blessed Virgin Mary, the basilica holds a special Novena service in Italian.

SANT'ANNA
di
Scranton

PADRI PASSIONISTI
Scranton, Pa.

Lucien Luciani shovels snow in 1958 at the original St. Francis of Assisi Parish in Scranton's South Side. The church was founded by Italian immigrants who worked in the Moffatt Coal Company's nearby shaft. In 1950, a new St. Francis of Assisi Church was dedicated just a few yards from the original, in response to a growing number of parishioners. (Courtesy of St. Francis of Assisi Parish.)

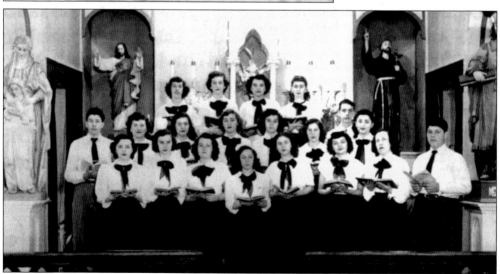

The St. Francis of Assisi Parish choir poses in 1948, in one of the few remaining photographs showing the interior of the old church. Pictured from left to right are the following: (first row) Lucille Vanvestraut, Eleanor Bisciaio, Ann Luciani, Theresa Dorio, Rose Gatti, Mary Contardi, Santa Montalbano, and Stephen Sabatini; (second row) Edward Notari, Vita Vanvestraut, Frances Notari, Tillie Tomarelli, Rose Sgobba, Angeline Curcio, and Josephine Cupple; (third row) Frances Mascioni, Ann Carlucci, Veronica Contardi, Lucy Tiberio, and unidentified. (Courtesy of St. Francis of Assisi Parish.)

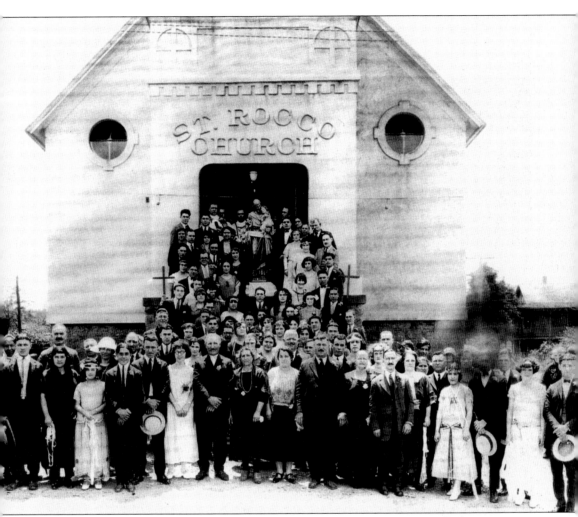

St. Rocco's Parish in Dunmore was established by immigrants—many of whom are seen in this photograph—who arrived in Dunmore's Bunker Hill section from Guardia dei Lombardi, Campania. The church was first organized by a group of men who created the Society of the Congregation of St. Rocco's Church, because St. Rocco is the patron saint of Guardia dei Lombardi. The church's first pastor was Fr. Clement Cavaletti, who came to Dunmore from Jessup on a weekly basis to offer Mass. The first resident pastor of St. Rocco's was Fr. Pasquale Pussomando, who was appointed to the position in 1922. The parish building was purchased from a group of Presbyterians who had previously used it for their services. (Courtesy of Carlo Pisa.)

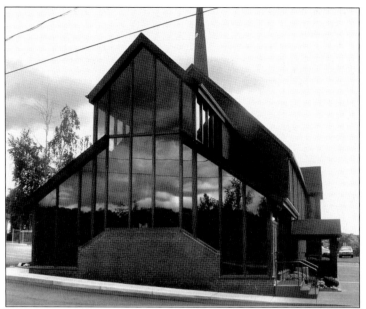

St. Rocco's Parish has undergone various changes in its nearly 100-year history; this photograph shows how the church looks today. In January 1999, a fire caused extensive damage to the interior. The parishioners rallied together and raised money to cover the repairs, which were not covered by insurance. (Photograph by Stephanie Longo.)

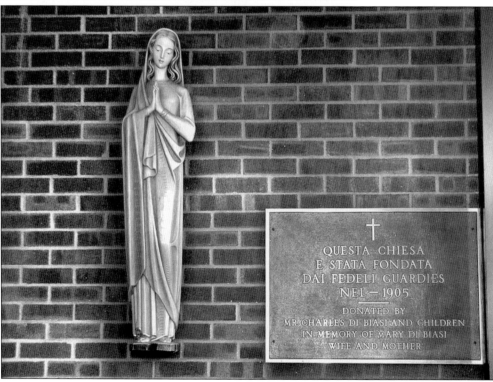

The parishioners of St. Rocco's, almost all of whom can claim ancestry from Guardia dei Lombardi, Campania, are very proud of their heritage. The plaque at the right reads, "*Questa Chiesa è stata fondata dai fedeli Guardiesi nel 1905,*" which translates to "This church was founded by the faithful Guardiesi in 1905." The plaque hangs on part of a wall that belonged to the original St. Rocco's Church, which is now enclosed in a glass porch-like area as can be seen above. (Photograph by Stephanie Longo.)

ℨILVER ℑUBILEE ℬANQUET

IN HONOR OF

Rev. William A. Crotti

and Dedication of ST. ANTHONY'S NEW CHURCH and SCHOOL
DUNMORE, PA.

SUNDAY, JANUARY 7, 1951

ARABIAN BALLROOM, HOTEL JERMYN

The new St. Anthony's Parish in Dunmore was dedicated on January 7, 1951, during a silver jubilee (25th anniversary) banquet to honor its pastor, Fr. William Crotti, at the Hotel Jermyn in downtown Scranton. Vincent Riggi, a prominent Dunmore architect, designed the new St. Anthony's as well as the new St. Mary's of the Assumption in Old Forge. Riggi was born in San Cataldo, Sicily, and immigrated to northeastern Pennsylvania with his mother in 1902. His oldest son, also named Vincent, has followed in his father's footsteps to become a well-known architect in the region. (Courtesy of Joe Pascoe.)

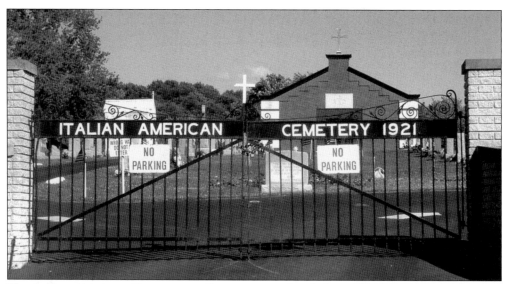

The Italian-American Cemetery in Scranton was founded in 1921 by a group of Italian immigrants who wished to be buried with other *paesani*. Within the cemetery are many graves dating from 1921 that bear epitaphs written in Italian. (Photograph by Stephanie Longo.)

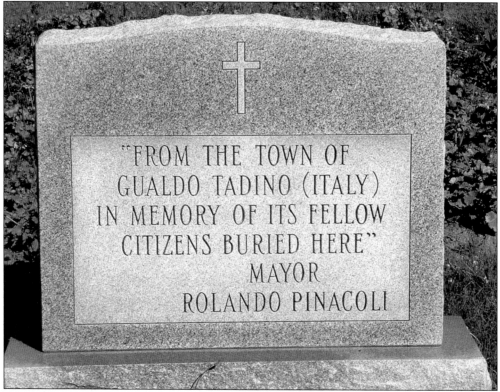

Since many people from Gualdo Tadino, Umbria, settled in northeastern Pennsylvania, Mayor Rolando Pinacoli donated this monument, which can be seen at the cemetery entrance, in honor of the people from that town who are buried in the Italian-American Cemetery. Gualdo Tadino was declared the sister city of West Pittston in the year 2000. (Photograph by Stephanie Longo.)

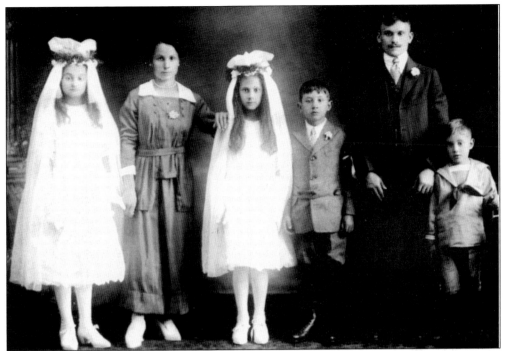

First Holy Communion was very important in the Italian Catholic household because it marked the children's first steps toward adulthood. They were now able to receive the Body of Christ. Nicola Rosi, who emigrated from Nocera Umbra, Umbria, to Pittston in the late 1890s, appears with his children on their First Holy Communion *c.* 1905. The children quite possibly attended Our Lady of Mt. Carmel Church in Pittston. (Courtesy of the Museo Regionale dell'Emigrazione of Gualdo Tadino, Italy.)

Italian weddings were known for being a festive family occasion where everyone was invited and only the best food was served. This photograph shows the wedding of Carmelo and Theresa Altieri Trovato on May 1, 1930, in Scranton. (Courtesy of John Trovato.)

Angelo and Rose Florey Fiorani (seated) were married in 1923 in Scranton. Seen with them are best man Peter Migliorino and maid of honor Theresa Ventre. (Courtesy of Rosemary Fiorani Gallagher.)

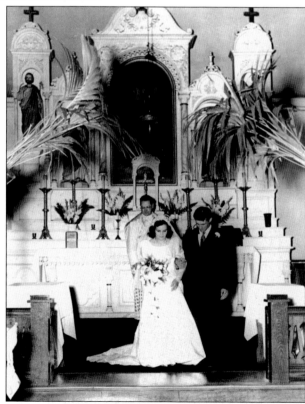

Mary Lemoncelli Merli described her July 12, 1947 wedding to Gino Merli as a "small but lovely affair." The wedding was held at St. Mary's Villa in Eynon, which has since been torn down. (Courtesy of Mary Lemoncelli Merli.)

Dolores Petrini and Felix Di Rienzo wed in Scranton on June 22, 1946. The Di Rienzos have now been married for 58 years. (Courtesy of the Di Rienzo family.)

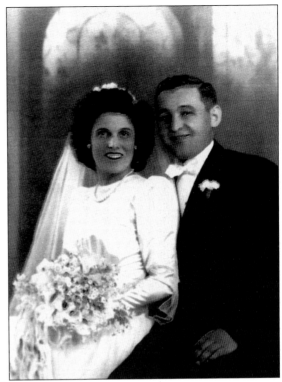

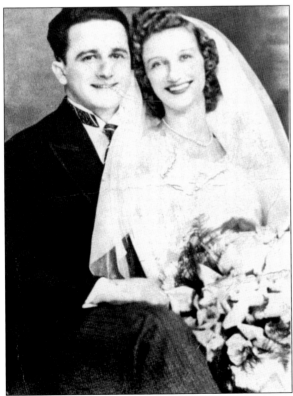

Robert and Louise Waitulavich Mascaro were married in the late 1940s in Scranton. In northeastern Pennsylvania slang, this marriage would have been called "interracial," as Robert was of Italian origin and Louise was of Polish origin. Many times in a mixed-ethnicity marriage, the families are not very welcoming of the "intruder." However, in the case of this couple, both families approved and respected them. The Mascaros enjoyed a happy marriage until Louise's untimely death in 1949 at age 29 from a brain tumor. (Courtesy of Ann Marie Longo.)

Anthony Pizzi stands with his nephew John Trovato on his Confirmation day in the 1940s. Confirmation was also important for the Italian-American family because it marked the completion of the child's entry into adulthood that was begun on First Holy Communion. The short pants that John is wearing were later replaced with long pants to symbolize his adulthood. (Courtesy of John Trovato.)

The Longos of Dunmore celebrate their son Joseph's Confirmation in 1956. The symbolism of the pant length had since fallen out of favor, and children began to wear robes to receive the sacrament. Pictured from left to right are Ann Marie, Anna, Joseph, and Joe Longo. Both Ann Marie and Joseph remember this day as a major celebration, with many people visiting the family and a lot of food prepared by their parents. (Courtesy of Ann Marie Longo.)

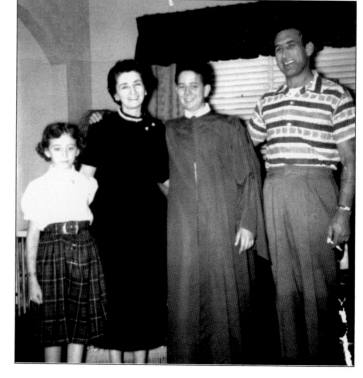

Five

PER RICORDARE

It can never be said that an Italian does not enjoy a good celebration. Italian-Americans are known for their pride in their ethnicity and for the festivals that they organize every summer in celebration of their heritage and traditions.

Many Italian communities throughout northeastern Pennsylvania hold annual festivals to remember their patron saint and to ask for his or her blessing for the town. The festivals typically follow a standard format: a Catholic Mass, a street procession with a statue of the town's patron saint, music, social activities on the church grounds, Italian food, and evening fireworks (Grifo and Noto 1990, 14). The festivals do not discriminate against non-Italian-Americans by forbidding them to participate in the event. For example, in Berwick, the Italians of St. Joseph's Church hold a festival in honor of Santa Maria Assunta. Their procession makes a stop at the Ukrainian Catholic Church of Saints Cyril and Methodius in order to add a community feeling to the festival (Grifo and Noto 1990, 14).

Not all Italian festivals are religious, however. Several in northeastern Pennsylvania were created to celebrate Italian food and culture, such as *La Festa Italiana* in Scranton and the Pittston Tomato Festival. These festivals were conceived as a way for Italian and non-Italian-Americans to discover the various ways that Italian culture has influenced the day-to-day life that we enjoy in this country.

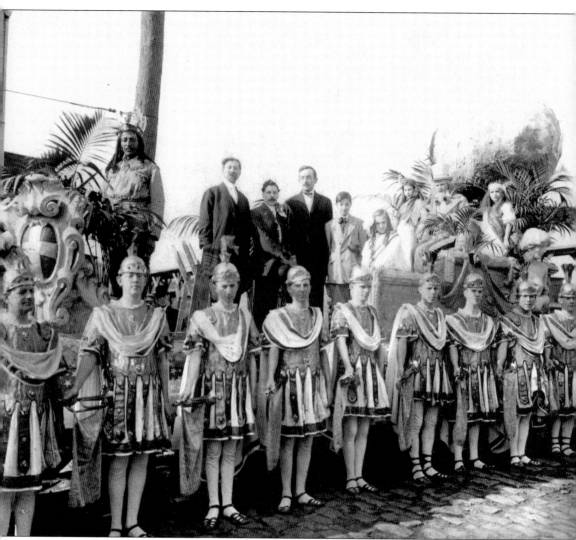

Scranton's first Columbus Day celebration occurred on October 21, 1892. That day, residents were awakened at 4:30 a.m. by a salute from the Griffin Post cannon. The activities began with a Mass celebrated by Bishop William O'Hara at St. Peter's Cathedral. Afternoon festivities were so large that all streetcars in downtown Scranton had to be stopped during the celebration and subsequent unveiling of the Columbus statue on Courthouse Square. The master of ceremonies for the event was Frank Carlucci, whose front yard served as the "studio" for the sculpting of the statue. (Courtesy of Vincent Riggi.)

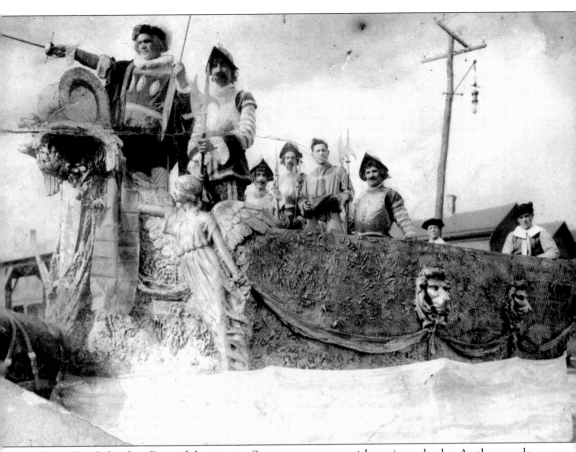

The 1892 Columbus Day celebration in Scranton was not without its setbacks. As the parade in honor of Columbus ended, people began to congregate on North Washington Avenue for the dedication of the statue of Christopher Columbus. The *Scranton Times* reported that controlling the crowd was a major problem because the "surging mass of people" was so excited by the events. The Scranton Police Department considered opening fire hoses on the crowd to gain control; however, police on horseback were able to cut a path through the crowd and succeeded in avoiding injuries. (Courtesy of Vincent Riggi.)

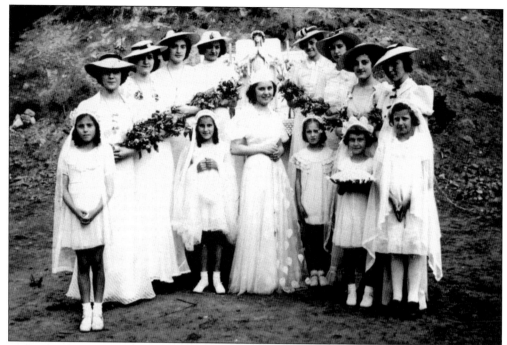

Marsilia Galli (center) is crowned the 1938 May Queen for St. Mary's of the Assumption Church in Jessup. May Crowning is a celebration common in many Catholic churches because it recognizes the Blessed Virgin Mary as the queen. Usually, a crown made of flowers is placed on the head of a statue of Mary by a young, unmarried woman belonging to the parish. (Courtesy of Joan Ondush.)

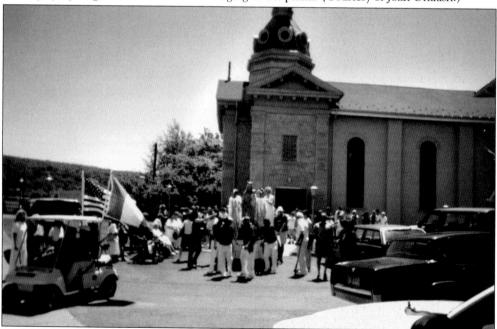

This festival and procession are in honor of Our Lady of Mt. Carmel Parish in Carbondale. The celebration was revived after a 10-year hiatus from 1962 to 1972 and continues to be held every July. (Courtesy of Sarah Gillatt.)

This scene depicts the procession of Our Lady of the Immaculate Conception, held in Carbondale. The festival was introduced to Carbondale in the 1920s by Sicilian immigrants from the town of Canicatti who wished to celebrate the Blessed Virgin Mary under her title of the Immaculate Conception, because she was the patroness of their hometown. (Courtesy of Joseph Martines.)

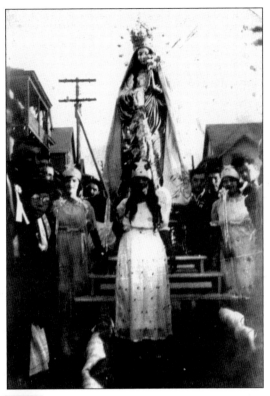

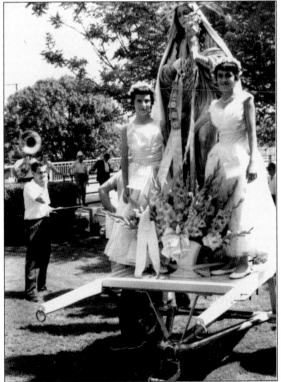

The Immaculate Conception procession was held in Carbondale until the 1960s, which is when this photograph was taken. The statue of the Blessed Virgin Mary was then set aside and forgotten about until 1983, when a group of parishioners of Our Lady of Mt. Carmel Church decided to raise funds to restore it. They gave it a permanent place in the church, where it remains today. (Courtesy of Joseph Martines.)

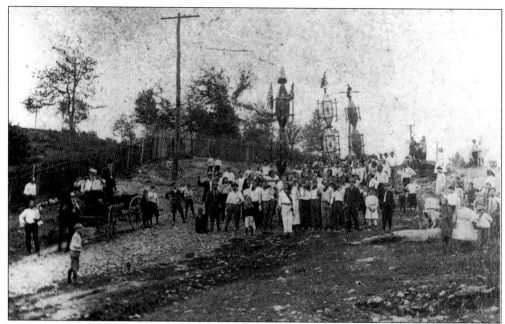

This *c.* 1915 photograph shows *La Corsa dei Ceri,* or the Race of the Saints, held every May in Jessup on St. Ubaldo Day. The *ceri* are three wooden structures displaying statues of the following saints: St. George, patron of tradesmen and merchants; St. Anthony, patron of peasants and laboring classes; and St. Ubaldo, patron of stonemasons. Each *cero* is carried by 10 men who are nicknamed *ceraioli.* The race tests strength, as each team must try to keep its *cero* perpendicular to the street. If a *cero* is dropped, it is considered a disgrace. (Courtesy of the Museo Regionale dell'Emigrazione, Gualdo Tadino, Italy.)

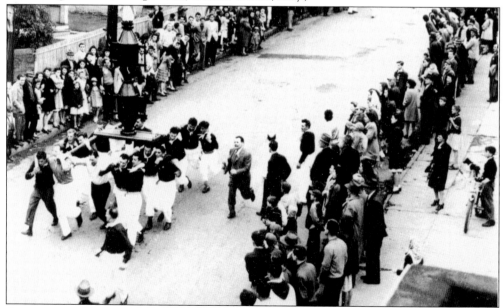

A *cero* is carried here in 1948. The Race of the Saints was brought to Jessup by immigrants from Gubbio, Umbria, whose patron saint is St. Ubaldo. The race has been held all over the world. (Courtesy of the Museo Regionale dell'Emigrazione, Gualdo Tadino, Italy.)

90

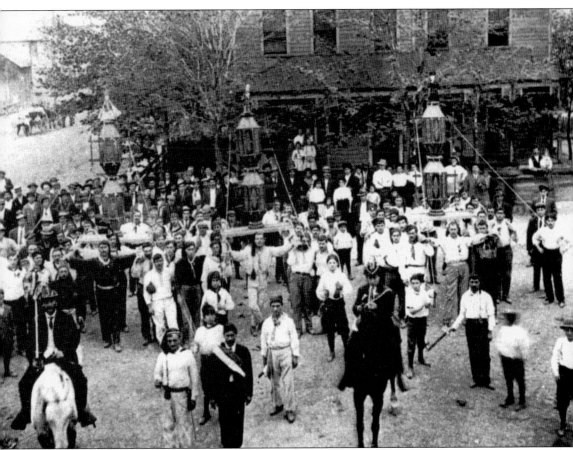

The three *ceri* are ready for the Race of the Saints in Jessup in 1920. The three different costumes used during the race have since been slightly modernized. In the 1920s, the costumes were as follows: for St. Ubaldo, the *ceraioli* wore white trousers with a yellow shirt and a red sash around the waist. The headgear was similar to a Turkish fez with a dangling tassel. The *ceraioli* for St. George donned white trousers, a blue shirt, and a red sash. Finally, the *ceraioli* for St. Anthony wore black trousers, a white shirt, and a black sash. The women, or *ceraiole*, wore colors corresponding to the saint whom they were supporting. (Courtesy of the Museo Regionale dell'Emigrazione, Gualdo Tadino, Italy.)

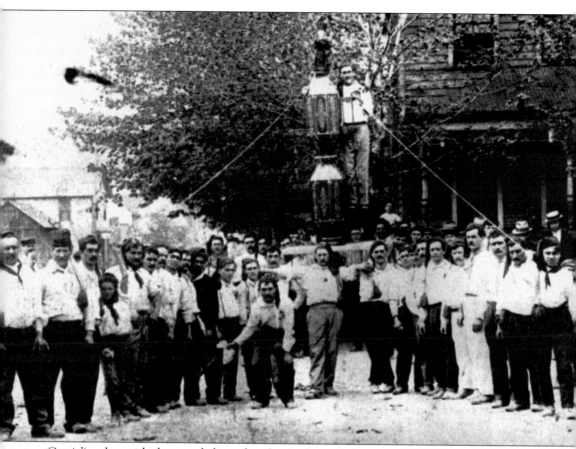

Ceraioli gather with the *cero* dedicated to St. Anthony in Jessup in 1920. Tradition has it that St. Ubaldo usually "wins" the Race of the Saints, symbolizing his protection of Gubbio twice from raging conquests while he was bishop. The first conquest was by a confederation of various Umbrian cities wanting to take over Gubbio in 1154, and the second was the next year, when Frederick I (Barbarossa) wished to conquer Gubbio during his conquest of Italy. Both times, St. Ubaldo's faith in God and His will helped St. Ubaldo to save his fellow citizens from danger. Legend also states that upon his return from negotiations with Frederick I (Barbarossa), St. Ubaldo was placed on a platform and paraded throughout the streets of Gubbio to show citizens that he was safe. (Courtesy of the Museo dell'Emigrazione, Gualdo Tadino, Italy.)

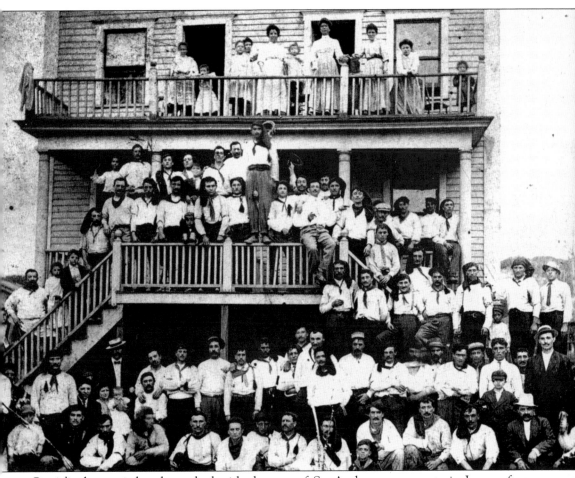

Ceraioli who carried and marched with the *cero* of St. Anthony congregate in Jessup after the Race of the Saints in 1915. At the festival's conclusion, the whole town gathers for a celebration of its heritage. Gubbio and Jessup have been declared sister cities because of the large number of *Eugubini* (people whose ancestors are from Gubbio) who live there. (Courtesy of the Museo dell'Emigrazione, Gualdo Tadino, Italy.)

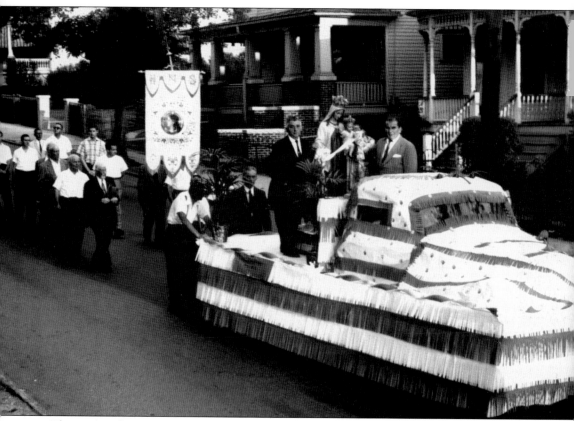

This 1950s photograph reveals the festival in honor of Our Lady of Mt. Carmel in Pittston. Instead of carrying the statue of the Blessed Virgin Mary by hand, volunteers place the statue on the back of a decorated automobile and stand beside it to protect it from falling, while parishioners walk behind. The procession continues to this day. (Courtesy of Our Lady of Mt. Carmel Parish.)

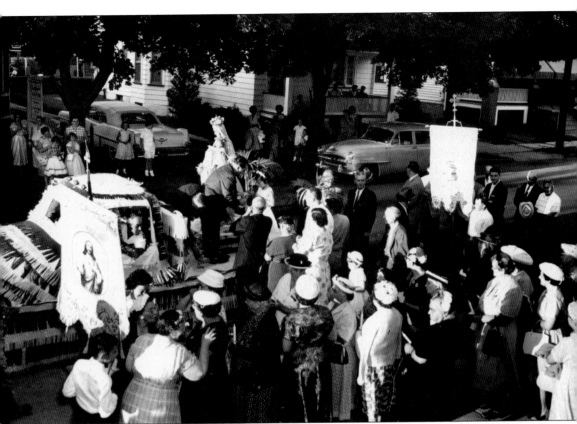

Sometimes people will attach money to a statue of the Blessed Virgin Mary while on procession, either to ask her intercession in the granting of a prayer or to offer thanksgiving for her aid. Here, parishioners of Our Lady of Mt. Carmel Parish in Pittston prepare to attach money to the statue of their patron saint during the 1950s. (Courtesy of Our Lady of Mt. Carmel Parish.)

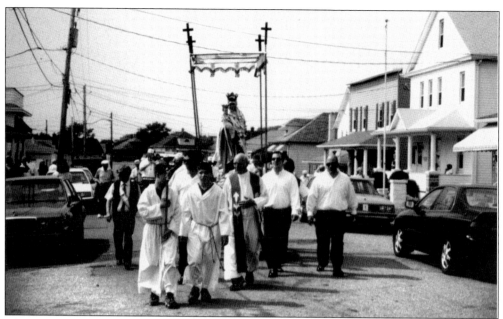

The procession of Our Lady of Constantinople occurs in Old Forge. Most of the Italians of Old Forge are descendants of immigrants from the village of Felitto, Campania. When these immigrants settled in Old Forge, they started an annual procession and festival to honor Our Lady of Constantinople, whom they believed helped them survive hard times. Both the festival and the procession were discontinued in the 1930s, but were revived in the 1980s. (Courtesy of Ray Rinaldi.)

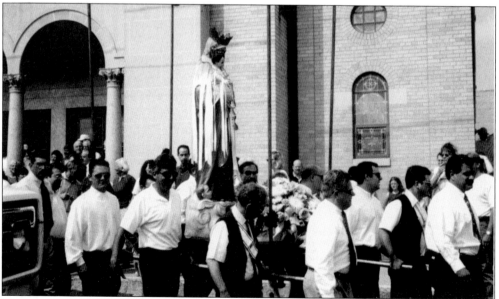

The veneration of Our Lady of Constantinople dates back to 1790 in Felitto. The morning of the Old Forge procession usually begins with a traditional Mass in her honor at St. Mary of the Assumption Church. The festival is meant to remember the town's Felittese origins and to pay homage to the shrine of Our Lady of Constantinople, which was built on Third Street by the Felittese Association. (Courtesy of Ray Rinaldi.)

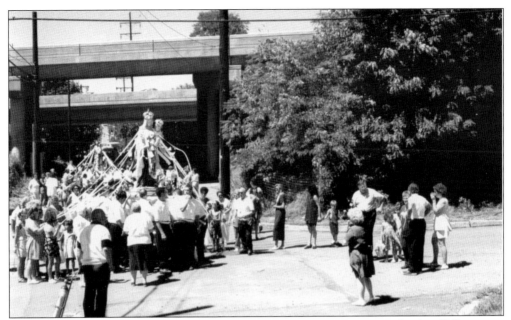

The procession in honor of St. Rocco is held every August in Dunmore's Bunker Hill section. For more than 70 years, it has taken place on the last day of a three-day festival in honor of the saint in Bunker Hill. The men of the parish carry statues of St. Rocco, the Blessed Virgin Mary, and St. Joseph over a 1.5-mile trail. (Courtesy of Carlo Pisa.)

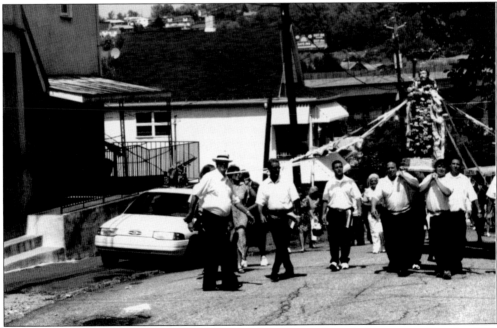

Carlo Pisa and his son Alfredo carry the statue of St. Rocco through the streets of Bunker Hill. Legend has it that St. Rocco, the patron saint of the invalid, saved the citizens of Guardia dei Lombardi, Campania, from plague and drought in the 1600s. St. Rocco then became the patron saint of Guardia dei Lombardi. When Guardiese immigrants arrived in Dunmore, they brought this tradition with them. (Courtesy of Carlo Pisa.)

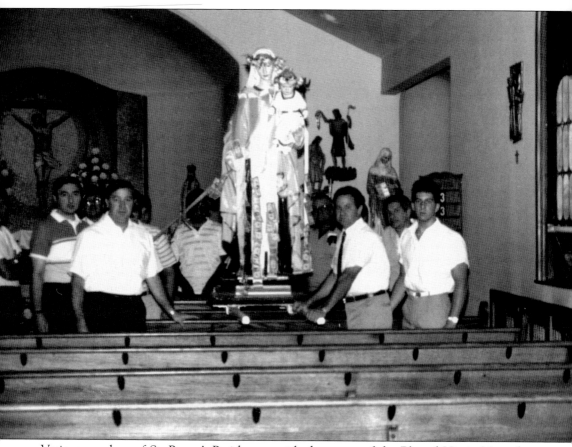

Various members of St. Rocco's Parish pose with the statue of the Blessed Virgin Mary that is carried in their annual procession in honor of St. Rocco. Even though the practice of this procession slowly lost popularity in the 1960s, more than 1,000 people still take part every year. At the end of the procession, a benediction occurs inside of St. Rocco's Church and worshipers are blessed with a relic of St. Rocco. Afterward, visitors can attend the parish's Italian Festival and feast on homemade Italian food in honor of St. Rocco. (Courtesy of Carlo Pisa.)

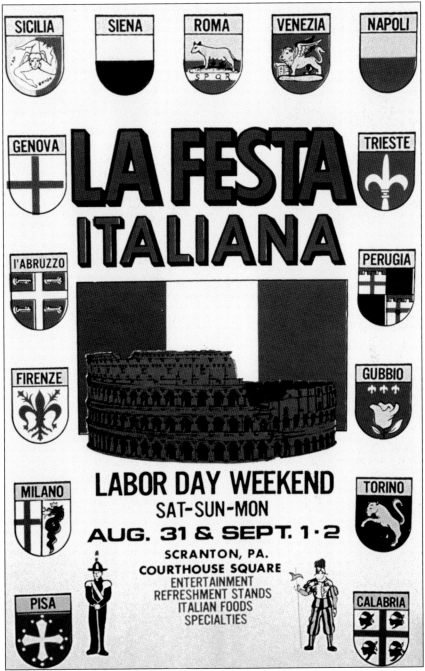

Northeastern Pennsylvania is home to *La Festa Italiana*, the largest Italian-American festival in the state, which is held on Courthouse Square in Scranton. The festival was originally started by Rose and Angelo Fiorani in the 1930s at Scranton's Rocky Glen Park, but was stopped after a few years due to mounting financial costs. *La Festa Italiana* was resurrected in 1976 by Lackawanna County commissioner Robert Pettinato on Columbus Day weekend as a way for the local Italian-American community to celebrate its heritage during the bicentennial year. (Courtesy of Guy Cali and Associates.)

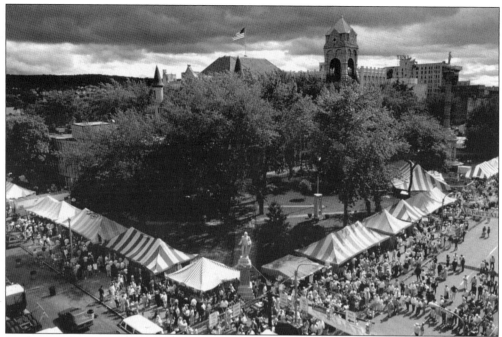

La Festa Italiana was originally held on Columbus Day weekend, but due to inclement weather, organizers were convinced that a change in season was needed. It was moved to Labor Day weekend in 1981 and has been held at that time ever since. (Courtesy of Guy Cali and Associates.)

Authentic Italian food, such as gelato imported from Milan, is a staple at *La Festa Italiana*. Vendors occupy all four sides of Courthouse Square in Scranton, offering a wide variety of Italian cuisine made by some of northeastern Pennsylvania's most noted Italian restaurants (Courtesy of Guy Cali and Associates.)

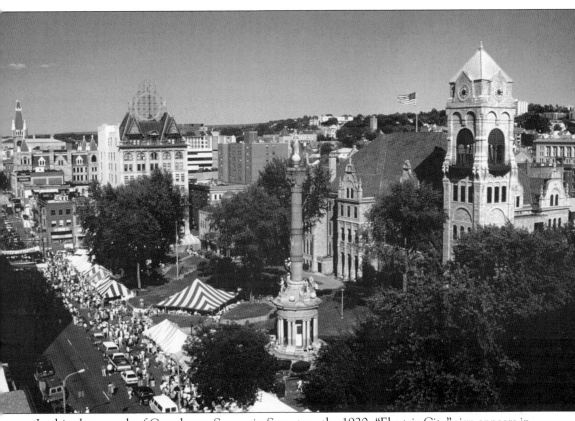

In this photograph of Courthouse Square in Scranton, the 1920s "Electric City" sign appears in the background, a remnant from the city's heyday as "coal capital of the world." *La Festa Italiana* was conceived to maintain Italian traditions; for example, in Italy, the *piazza* is the center of the community, where festivals are held to honor the saints and where townspeople gather to discuss various topics. Scranton's Courthouse Square was chosen as the site for *La Festa* because it is the city's equivalent of a *piazza*. (Courtesy of Guy Cali and Associates.)

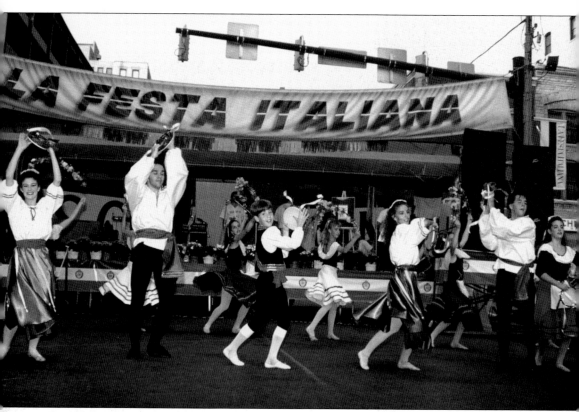

Dancers perform the *tarantella* in the middle of Scranton's Washington Avenue, closed to traffic during *La Festa Italiana*. Another highlight of the celebration is *La Messa Italiana*, a Mass performed entirely in Italian at St. Peter's Cathedral. Volunteers proceed into the cathedral while bearing the coats of arms from various Italian cities whose citizens immigrated to Scranton and its surrounding areas. (Courtesy of Guy Cali and Associates.)

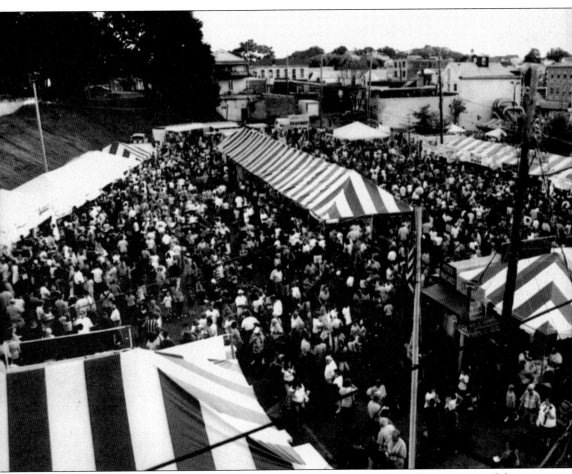

The Pittston Tomato Festival was started in 1983 as a way for residents of Pittston to celebrate their Italian heritage. It includes many events, such as a parade, a beauty pageant, and the Little Miss and Mr. Tomato Contest. A major highlight is the Tomato Contest, in which growers are encouraged to enter their tomatoes to be named largest, smallest, ugliest, or most perfect. Pittston has been nicknamed the "Tomato Capital of the World," because the city's acidic soil, left over from the coal-mining era, helps create excellent crops of tomatoes that are shipped all over the country. (Courtesy of Lori Nocito.)

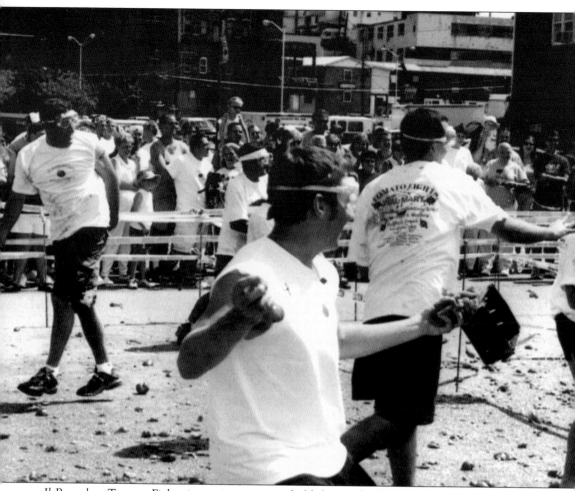

Il Pomodoro Tomato Fights is a unique contest held during the Pittston Tomato Festival. The object is to squash and throw tomatoes at as many people as possible. The contest is usually held in the parking lot of Cooper's Restaurant in downtown Pittston, where 20 teams of 10 people are given T-shirts and goggles to wear and cases of tomatoes to throw at their opponents. Proceeds from the Tomato Fights are used to support various charities throughout northeastern Pennsylvania. (Courtesy of Lori Nocito.)

Six

TUTTO DURA

The Italian-Americans of northeastern Pennsylvania have fulfilled the second proverb mentioned in the beginning of this book, which states that if a person takes care of what has been planted, it will last. The immigrants who arrived here planted the seeds of families that now contribute to the strong sense of cultural identity in the region. In a recent conversation, renowned jewelry designer Richard Palermo, originally from Dunmore, stated: "More Italian Americans should maintain a sense of pride about their heritage. It saddens me that the image even today of Italians is blurred by the media. As long as it sells TV programming, the media will continue to use Italian Americans as scapegoats for profit and portray them as cigar-smoking, garlic-eating thugs with moustaches that kill people before going to Mass on Sunday! It is a great injustice, why do we as Italian-Americans allow it?"

Besides pride in their ancestral land, the Italians of northeastern Pennsylvania also take great pride in their adopted land. Frank Stella, former president and chairman of the National Italian American Foundation, was born and raised in Jessup. He likened growing up in northeastern Pennsylvania to growing up in a "foreign land" because, as the first American-born generation in this multi-cultural area, every day was an interesting one. Even film director Michael DiLauro, born in Columbus, Ohio, admits, "Northeastern Pennsylvania is unique because, despite its isolated and deprived nature, it makes the best of what it has and even though it is currently in the midst of a Renaissance, it has held on to its heritage."

Holding on to heritage is precisely what the Italians of northeastern Pennsylvania have done, and what they will continue to do until the end of time.

The enduring spirit of the Italians of northeastern Pennsylvania is exemplified by this photograph of Luigi and Maria Antonia Fanucci Galli of Scheggia, Umbria, who immigrated to Jessup in the early part of the 20th century. Both Luigi and Maria Antonia passed away in the 1920s, but this image was lovingly preserved by their children until the 1960s, when the family home at 316 Front Street burned to the ground. The photograph was miraculously found intact in the rubble, proving that history can never really die or be destroyed. (Courtesy of Joan Ondush.)

CALITRANI DAY REUNION

Calitrani Day was held annually by the Calitrani of Dunmore until *c.* 1962. Various descendants of the original immigrants from Calitri, Campania, decided to reorganize and hold another Calitrani Day in 1992 as a celebration of the strength and fortitude of their ancestors. Here, the De Maio family of Dunmore celebrates at Calitrani Day in 1992 at St. Anthony's Field. (Courtesy of Rosemary De Maio Fariel.)

Italian-Americans owe a particular debt of gratitude to Neil Trama, seen here with his wife, Isabelle Pizzo Trama, as he was responsible for Columbus Day being declared a national holiday. Mounting a grass-roots campaign of letter writing and public speaking, he urged support for the holiday, saying: "Without Christopher Columbus, we would have no Thanksgiving Day, no Memorial Day, no Labor Day, and no Election Day. Columbus Day is for all Americans and for all the Americas." Thanks to Neil Trama and his dedication, Columbus Day was declared a national holiday in 1971. He continued to be an avid supporter of Columbus Day, as well as other aspects of his Italian-American heritage, until his death in early 2004. (Courtesy of Neil C. Trama.)

Pennsylvania senator Raphael "Ray" Musto (left) of the state's 14th District was born in Pittston to an Italian-American family. He continues to support Italian-American initiatives in his senatorial work, most notably the restoration of the chapel at Letterkenny Army Depot in Chambersburg, which was constructed in 1945 by Italian prisoners of war. Seen with Senator Musto is Dr. Alfred Tonolo, a former Italian soldier, captured during World War II, who participated in the building of the Letterkenny Chapel. Dr. Tonolo fell in love with the United States and, after his release, sent for his family.

Director Michael DiLauro is originally from Cleveland, Ohio, but now calls Scranton home. He is a descendant of immigrants from the province of Foggia, Puglia. His documentary, *Prisoners Among Us*, was based on the story of Italian detainment camps in the United States during World War II. (Courtesy of Michael DiLauro.)

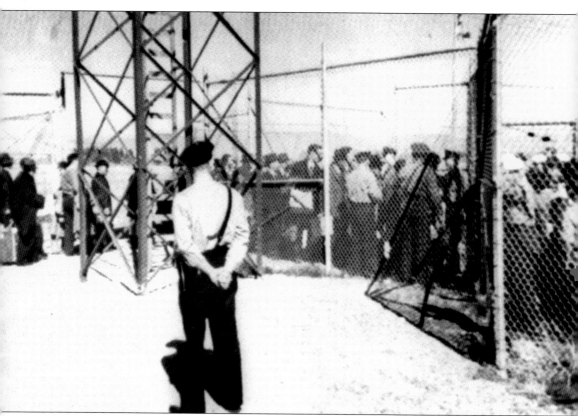

This photograph, used in *Prisoners Among Us*, shows Italian detainees being sent to internment camps in the United States during World War II. Many detainees were sent to these camps, not because they were a threat to the United States, but simply because they were of Italian origin. More than 10,000 were deemed "enemy aliens" by the United States government. (Courtesy of Michael DiLauro and the Mike and Maureen Mansfield Library of the University of Montana.)

Seen here are "mug shots" of the so-called Italian "enemy aliens" of World War II. Through his documentary, Michael DiLauro wanted to tell the story of these people in an engaging way so that there would be no more shame in the experience. (Courtesy of Michael DiLauro and the *Una Storia Segreta* exhibit.)

Frank Stella is the son of Facondino and Chiara Stella, who emigrated from Gualdo Tadino, Umbria, to Jessup. The founder and president of Stella Foods Corporation of Detroit, Michigan, Frank served as president and chairman of the National Italian American Foundation for more than 20 years. He admits that his passion for his Italian heritage began during his childhood in Jessup, because the town was one-third Italian, one-third Irish, and one-third Polish. He was constantly surrounded by a variety of cultures, and so looked to his own. (Courtesy of Frank Stella.)

This image shows some of Pennsylvania's delegation to the National Italian American Foundation in Washington, D.C. Pictured from left to right are Rose Basile Green, author and professor from Philadelphia; Frank Stella, originally from Jessup; and Frank Carlucci, grandson of architect Frank Carlucci from Scranton. The younger Frank Carlucci, born in Wilkes-Barre, served as secretary of defense under Pres. Ronald Reagan. (Courtesy of the National Italian American Foundation.)

While visiting Guardia dei Lombardi, Campania, during the 1980s, Monsignor Constantine Siconolfi of Scranton took this photograph of his family in the kitchen. Many families in the Italian countryside still live in settings like this. (Courtesy of Monsignor Constantine Siconolfi.)

Monsignor Constantine Siconolfi stands before his ancestral hometown of Guardia dei Lombardi, Campania. Monsignor Siconolfi is best known throughout northeastern Pennsylvania as the founder of St. Francis of Assisi Food Kitchen in downtown Scranton. Monsignor Siconolfi has admitted that his life would be "dull and nondescript" without his Italian heritage, of which he is extremely proud, having grown up in Dunmore's Bunker Hill section amidst many immigrants from Guardia dei Lombardi. (Courtesy of Monsignor Constantine Siconolfi.)

A woman pauses with what is left of her belongings after an earthquake hit the Irpinia Valley of Campania, from whence many residents of northeastern Pennsylvania can claim ancestry, on November 23, 1980. Immediately following the earthquake, Lackawanna County commissioner Robert Pettinato called a meeting to try to decide what could be done to help the victims. More than $50,000 was raised throughout the county, and a delegation of eight people, including Monsignor Siconolfi, traveled to Irpinia to present the money directly to the victims. Monsignor Siconolfi also stopped to give money to the priests to help fix Santa Maria delle Grazie, the mother church of Guardia dei Lombardi, which was heavily damaged in the quake. (Courtesy of Pino and Lino Sorrentini.)

The reconstructed Santa Maria delle Grazie of Guardia dei Lombardi, Campania, was opened in the 1990s. Inside the church, a plaque thanks the residents of Scranton for their help in the restoration process after the 1980 earthquake. Santa Maria delle Grazie was built in the 1600s and has served as the most important church—and the tallest building—in Guardia dei Lombardi ever since. (Courtesy of Salvatore Boniello.)

Sal Nardozzi Jr. slides a fresh pizza into the oven to be baked at Nardozzi's Pizzeria in Dunmore. He has always been proud of his Italian-American heritage and his northeastern Pennsylvanian roots, most notably by being a founding member and officer of the first student chapter of the National Italian American Bar Association while in law school at Ohio Northern University. (Photograph by Stephanie Longo.)

Nardozzi's Pizza has been a community staple since the 1960s. The Nardozzi family emigrated from the province of Naples, Campania, considered the "birthplace" of pizza. Someone cannot open a pizzeria there without it being certified by the city's official Pizza Board to make sure it complies with the high standards of Neapolitan pizza. Nardozzi's is one of the few places in northeastern Pennsylvania where pizza is made in this authentic Neapolitan style. (Photograph by Stephanie Longo.)

Most pizzerias in northeastern Pennsylvania make their pizza in the "Old Forge style," as Old Forge is considered the "Pizza Capital of the World." *USA Today* ranked its pizza number one in the United States, and even pizza makers in Naples, Campania, refer to rectangular-shaped pizza as Old Forge style. Beginning with Revello's, the town's first pizzeria, Old Forge has been known as one of the region's best places to find delicious pizza and authentic Italian food. Ten pizzerias in Old Forge besides Revello's are part of the Pizza Capital of the World: Augustine's Club 17, Maxie's, Talarico's, Salerno's, Anthony's, Rinaldi's, Brutico's, Mary Lou's, Arcaro and Genell's, and Brownie's.

Italian-American artist Mike Trovato continues in the footsteps of Gonippo Raggi, having painted the portrait of Monsignor Paul Cottone that hangs in the entryway of St. Lucy's Parish. This portrait depicts Trovato's uncle Gus, an Italian emigrant from Sicily who settled in Scranton. Trovato has lived in Scranton all of his life and currently owns the SoHo Art Gallery. (Courtesy of Mike Trovato.)

Bishop Joseph Francis Martino, originally of Philadelphia, was installed as the ninth bishop of the Diocese of Scranton on October 1, 2003. Bishop Martino's installation is particularly significant in northeastern Pennsylvania's Italian-American history because he is the very first Italian-American to hold the office of bishop of the Diocese. There have been several Italian-American auxiliary bishops, most recently Bishop Francis X. DiLorenzo, currently bishop of the Diocese of Honolulu, Hawaii. (Courtesy of the Diocese of Scranton.)

Richard Palermo was born in Scranton in 1947 and was raised in Dunmore. His career as a world-renowned jewelry designer has spanned more than 30 years and has seen many prestigious international awards, including the Pearl Utopia International Design Prize and the American Gem Trade Association Spectrum Award. He has created his own signature line of fine jewelry, the Palermo Collection, which is sold in department stores and through independent jewelers in the United States, Canada, and the Caribbean Islands. Palermo is currently the director of design and merchandising for Color Craft in New York City. (Courtesy of Richard Palermo.)

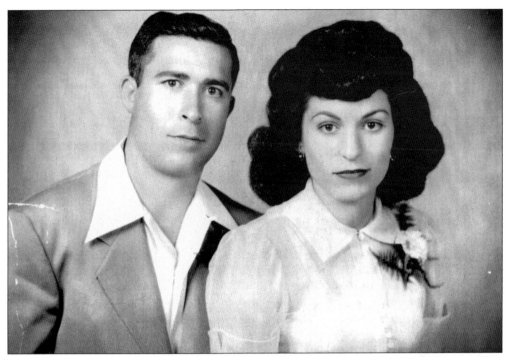

Richard Palermo's parents, Ross and Louise, seen here in 1949, raised their children with a strong sense of pride in their heritage. Besides Richard, the Palermos have three other children: Vincent, Ross Jr., and Elaine. As demonstrated in the introduction to this chapter, Richard believes that the Italian-American community should better promote the positive aspects of its heritage and end the mafia stereotype once and for all. (Courtesy of Richard Palermo.)

"I have been working for over thirty years to elevate my name 'Palermo' to the image of style, class, and elegant jewelry and not the image of a city where the 'mob' was born," Richard Palermo once said. This photograph is just a sampling of his many designs for Color Craft. He combines exquisite gemstones with precious metals to evoke a true sense of luxury in his jewelry. (Courtesy of Richard Palermo.)

Ann Marie Longo stands in her Scranton kitchen with her *pizza 'chiena* (Easter pizza, seen at left) and gnocchi (seen below). She is the creator of Annie's Italian Specialties, an innovative way of selling authentic, home-cooked Italian food via the Internet so that others may taste "real" Italian food instead of the watered-down versions found in many restaurants. Thanks to modern technology, Annie's Italian Specialties is a growing business not just in northeastern Pennsylvania but also all over the United States. (Courtesy of Ann Marie Longo.)

Ann Marie Longo wanted to be a barber like her father, Joe, with whom she is seen here in 1951. Joe would not hear of his daughter going to barber school and, instead, sent her to beauty school, where she received her teacher's license. She owned several beauty shops in Dunmore in the 1970s, and began cooking on the side to earn extra money. Joe taught his daughter the traditional cuisine of Guardia dei Lombardi, Campania, where he was born. Today, Ann Marie continues to cook in the traditional Guardiese style, but upon developing Annie's Italian Specialties, she decided to create modern variations on her father's time-honored recipes for a new spin on authentic Italian cuisine. (Courtesy of Ann Marie Longo.)

Modern technology allows many families to reunite, even with relatives they never knew they had. Here, Claudia Cerra (left) appears with her great-aunt Lena Louisa Volpe Tolerico in Carbondale. Lena had a sister who emigrated to England, while Lena emigrated to the United States from Cerrisi, Calabria, to be with her father. The families lost touch after Lena's sister passed away. Later, her sister's sons Aldo and Fiore began to work on a family history, finding Lena's daughter Caterina via the Internet. The two began to correspond and met while Caterina and her family visited England several years ago. This photograph was taken while Claudia, Aldo's daughter, was in the United States visiting her great-aunt Lena and her family. (Courtesy of Caterina Tolerico Refice.)

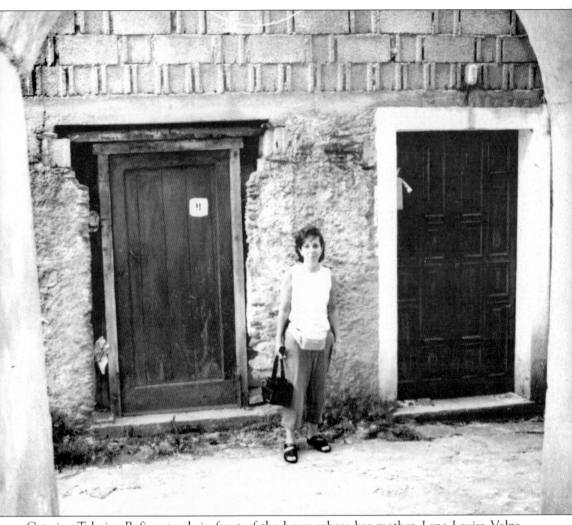

Caterina Tolerico Refice stands in front of the house where her mother, Lena Louisa Volpe Tolerico, was born on July 8, 1927. This image is truly representative of the Italian-American experience in northeastern Pennsylvania because it shows how the community has come full circle. The Italians arrived in northeastern Pennsylvania as immigrants from places such as Cerrisi, Calabria, where this photograph was taken. Now, future generations are expressing a desire to reconnect with the land their families left behind by doing genealogical research and by visiting their family's former homes in Italy. The Italians of northeastern Pennsylvania will continue to be proud of their heritage and will always be grateful to their forebears, who gave them the opportunity to grow up Italian-American in one of the most ethnically diverse regions in the United States. (Courtesy of Caterina Tolerico Refice.)

The Republic of Italy, with its capital at Rome, is divided into a series of 20 regions that roughly correspond to states in the United States of America. The regions are then subdivided into provinces, named for their largest city, which correspond to American counties. Therefore, the city of Roma (Rome) is in the province of Roma in the region of Lazio.

BIBLIOGRAPHY

Boniello, Salvatore. *Milleuno detti e proverbi dialettali di Guardia dei Lombardi e dell'Alta Irpinia.* Lioni: Poligrafica Irpina, 1999.

————. *Sulle orme del passato.* Lioni: Rotostampa, 2001.

CRESM Campania. *Atti dei seminari di studi desanctisiani: Francesco De Sanctis: il critico, l'uomo, il politico.* Lioni: Rotostampa, 2001.

Gambino, Richard. *Blood of my Blood: The Dilemma of the Italian Americans.* Toronto: Guernica, 1974, 1996.

Grifo, Richard D. and Anthony F. Noto. *The Italian Presence in Pennsylvania.* University Park: Pennsylvania Historical Association, 1990.

Istituto per la Storia dell'Umbria Contemporanea (ISUC). *La terra delle promesse.* Milan: Electa, 1989.

LaGumina, Salvatore J. *Wop! A Documentary History of Anti-Italian Discrimination in the United States.* Toronto: Guernica, 1999.

LaSorte, Michael. *La Merica: Images of Italian Greenhorn Experience.* Philadelphia: Temple University Press, 1985.

Malpezzi, Frances M. and William M. Clements. *Italian American Folklore.* Little Rock: August House, 1992.

Nardelli, Dino Renato. *Per terre assai lontane.* Foligno: Editoriale Umbra, 2002.

Serra, Ilaria. *Immagini di un immaginario: l'emigrazione Italiana negli Stati Uniti fra I due secoli (1890–1924).* Verona: Cierre Edizioni, 1997.

Scartezzini, Riccardo, Roberto Guidi, and Anna Maria Zaccarria. *Tra due mondi: L'avventura americana tra i migranti italiani di fine secolo.* Milan: FrancoAngeli, 1994.

BOOKLETS

A Guide to Outdoor Sculpture: Lackawanna County, Pennsylvania. Scranton: Lackawanna Historical Society with SOS (Save Outdoor Sculpture), 2003.

The Italians In Pennsylvania. Pennsylvania Historical and Museum Commission, 1988.

Mater Dolorosa Church: 1908–1983. Williamsport: Mater Dolorosa Church, 1983.

St. Anthony of Padua Church Diamond Jubilee: 1913–1988. Scranton: St. Anthony of Padua Church, 1988.

St. Francis of Assisi Parish: 1920–1995. Scranton: St. Francis of Assisi Parish, 1995.

St. Lucy's Church: 1901–2001. Scranton: St. Lucy's Church, 2001.

St. Mary of the Assumption Centennial Celebration: 1897–1997. Old Forge: St. Mary of the Assumption Church, 1997.

Who We Are, Where We Came From. Wilkes-Barre: *Times Leader,* 2003.

MAGAZINE

Ghost Wings. Summer/Fall 2000. Volume 1, issue 4.

INTERVIEWS

DiLauro, Michael. In-person interview. Scranton. March 25, 2004.

Di Rienzo, Felix and Dolores. In-person interview. Scranton. May 27, 2004.

Fariel, Rosemary De Maio. In-person interview. Scranton. June 12, 2004.

Gallagher, Rosemary Fiorani. In-person interview. Scranton. March 30, 2004.

Merli, Mary Lemoncelli. In-person interview. Peckville. April 2, 2004.

Moeller, Jennie Luongo. In-person interview. Scranton. December 22, 2002.

Palermo, Richard. In-person interview. Scranton. July 6, 2004.

Pascoe, Joseph. In-person interview. Carbondale. June 15, 2004.

Rettura, John. In-person interview. Scranton. March 24, 2004.

Siconolfi, Monsignor Constantine. In-person interview. Scranton. March 23, 2004.

Staff of Luzerne County Tourism Board. Telephone interview. Scranton to Wilkes-Barre. March 19, 2004.

Staff of Northeastern Pennsylvania Visitors Bureau. Telephone interview. Scranton. March 19, 2004.

Stella, Frank. Telephone interview. Scranton to Detroit. June 24, 2004.

LETTERS

Boniello, Salvatore. Various letters to Stephanie Longo from April 2002 to July 2004.

Cancelmo, Caroline. Letter to Stephanie Longo. June 2004.

TOURS

Lackawanna Historical Society. Monroe Avenue, Scranton. March 22, 2004.

Pennsylvania Anthracite Heritage Museum. McDade Park, Scranton. March 19, 2004.

NEWSPAPERS

Flannery, Joseph X. Various Articles. *Scranton Times.* 1990–2001.

"Police Guard House of Italian Priest." *Scranton Times.* April 25, 1907, p. 1 and 11.

"This Is Italy's Day." *Carbondale Leader.* July 24, 1890, p. 3.

THESIS

Scott, W. Roger. "Wyoming Valley: A Social History of an Immigrant Community." Thesis presented for the A.B. Degree with Honors in History. Kenyon College, 1973.